MARKETING & SELLING TECHNIQUES

FOR DIGITAL PORTRAIT PHOTOGRAPHY

KATHLEEN HAWKINS

AMHERST MEDIA, INC. ■ BUFFALO, NY

ACKNOWLEDGMENTS

Special thanks goes out to everyone who contributed to this project. Each one of you has touched my life in a very special way. You have shared an idea, a tip, or an image that opened my eyes and improved our business. Each of you were hand-picked based upon your tremendous talents and your warm, loving hearts. It takes a confident, successful businessperson to share their marketing ideas with their own peers and competition. Your contribution and willingness to share your thoughts, tips, and talents with the photographic industry is very much appreciated. The photographic industry, as well as your clients, have truly been blessed by your incredible gifts. Thank you!

Front cover photograph by Gregory Daniel.
Back cover photographs by Kathleen Hawkins (top) and Jeff Hawkins (center and bottom).

Published by:
Amherst Media, Inc.
P.O. Box 586
Buffalo, N.Y. 14226
Fax: 716-874-4508
www.AmherstMedia.com

Publisher: Craig Alesse
Senior Editor/Production Manager: Michelle Perkins
Assistant Editor: Barbara A. Lynch-Johnt

ISBN: 1-58428-163-4
Library of Congress Card Catalog Number: 2004113079

Printed in Korea.
10 9 8 7 6 5 4 3 2 1

TABLE OF CONTENTS

INTRODUCTION .5

1. IDENTIFY YOUR MARKET .11
 Finding Your Niche .12
 Appealing to Your Market .16
 Education .21

2. REFERRAL PROGRAMS AND PROMOTIONS23
 Watch Me Grow .24
 Little Wonders .25
 Summer Vacation Portrait Experience26
 Getaway Sessions .27
 Lifetime Portrait Programs .28
 Special Offers .29
 The Next Chapter .32

3. ADVERTISING AWARENESS .33
 Website Design and E-Commerce34
 Direct Mail .37
 Business Displays .40

4. BOOKING A SESSION .44
 Studio Management Software44
 Phone Skills .45
 Deposits/Retainers .48

5. THE PRE-SESSION CONSULTATION53
 The Studio Environment .53
 The Client's Role .56
 Maternity Sessions .59
 Baby-Portrait Sessions .60
 Holiday Sessions .64
 Special-Event Sessions .65
 Portrait Contracts .67

6. THE DIGITAL DIFFERENCE: PROFESSIONAL OPINIONS70

 Gregory and Lesa Daniel .70

 Frank Donnino .71

 Kay Eskridge .72

 Sherri Ebert .75

 Jamie Hayes and Mary Taylor-Fisk78

 Jeff Hawkins .79

 Charles and Jennifer Maring .82

7. CONDUCTING THE SESSION .83

 Narrative Environmental Sessions83

 Classic Studio Portraits .85

8. PREPARING PROOFS .89

 Proofing Workflow .89

 Proofing Methods .90

 Professional Opinions .93

 A Variety of Tools .96

9. PRODUCTS AND MERCHANDISING97

 Product Presentation .97

 The Whole Story .99

 Album Design Tips .102

 Ten Marketing Rules for Albums and Frames103

10. SOFTWARE .108

 Studio Management Software108

 Workflow Management Software111

Appendix 1: Sample Forms .112

Appendix 2: Sample E-Mail Correspondence119

Appendix 3: Contributors and Resources122

About the Author .123

Index .124

INTRODUCTION

Think back to when you were in high school. Do you remember having a subject you liked best and one you hated? If you had homework that night, you most likely completed the assignment for the subject you preferred and procrastinated when it came to doing the one you hated. Do the worst first! Photograph by Sherri Ebert.

With the implementation of digital technology and the rapid changes in the photography industry, digital portrait photography now requires a new set of skills that differ from those used in film photography. The way you market those skills needs to be adapted as well. Digital integration requires planning and constant education, which in turn requires time and time management.

Many photographers spend hours on the computer devouring the new technology and eventually neglect their business and their families. Often, they are so focused on being photographers, they forget they are running a business and have a difficult time understanding why they are not making a profit. This is a dangerous path to travel.

Think back to the time when you were in high school. Do you remember having a subject you liked best and one you hated? If you had homework that night, you most likely completed the assignment for the subject you preferred and procrastinated when it came time to do the one you hated. As adults, we do the same thing: you may put your focus on photography or on Photoshop and neglect to consider that if so much of your business has changed (equipment, products, style of images), then your marketing efforts should change as well. As an instructor, we used to encourage our students to "do the worst first." Today, I am just preaching "do it or delegate it!"

Before beginning this journey, get in the right frame of mind! Image by Maring Lifestyle Photography.

■ OBSTACLES TO SUCCESS

It's easy to get caught up in the day-to-day responsibilities of running a studio. Unfortunately, doing so can cause you to lose sight of the big picture. Ultimately, you want to ensure that you are successful—define

that term as you may! Take a look at the following questions and tips; they will help you to identify and correct some common problems faced by studio owners.

- **Do you have balance in your life?** When someone is consumed by their business, they don't have much left to offer others. Discuss your new business goals with your personal and professional associates. Establish clear guidelines for what is considered educational time, work time, and personal time. No matter how successful you may feel, it is important not to work all day, every day. It is also important that you balance educational and social time and not confuse them with revenue-generating activities.
- **Do you track your activities to determine the best use of your time?** While it is never a bad idea to run every aspect of your business, you should never take on too much responsibility yourself. Whether your studio is big or small, the abili-

Don't work all day, every day! Image by Maring Lifestyle Photography.

To make these portrait techniques work for your studio, you must avoid digital detours. Unfortunately, that is easier said than done. While photographers make the transition to digital with the best intentions, many become overwhelmed and quit soon after they start. To stay focused during this critical period, you must map out a realistic course of action, research your options, and develop a plan prior to starting. Change is constant. Once you implement a new plan and begin to feel comfortable, you will most likely need to try something new!

ty to delegate is key. Always ask yourself, "Can I make more money if I pay someone else to complete this task?" While a do-it-yourself mind-set may seem like a cost-effective approach, consider the time involved in completing each task. If you spend countless non–revenue generating hours at the computer trying to get your website up and running, it is probably not cost-effective for you to design your own site. On the other hand, if you hire a top-notch website designer to work on your site, how many photo sessions would it take to recoup the money you spent? On another note, what type of revenue-generating activities could you complete if you hired someone to assemble albums for your studio? Just because you delegate doesn't mean you dismiss! Follow-up and supervision is the key to quality control.

- **Do you have a well-defined plan for your future?** Do you know where you are going before you get there?

- **Do you run your business, or does your business run you?** Developing a workable timeline will help you stay on task and speed up your workflow. Using the old film-based workflow, it took two weeks or longer to have images developed and processed. With the new digital system, images can be ready for view-

Have a plan. Know where you are going before you get there! Image by Gregory Daniel.

ing as quickly as the studio wants to show them. No matter which viewing timeline the studio or client prefers, the digital process allows clients to receive their finished product within six to eight weeks from their final session—even the popular library-bound albums. However, sometimes expediting your workflow too much can backfire! Just because you can do something fast, doesn't mean you should. What would provide a better, higher-quality meal: a fast-food restaurant or a fine dining establishment? Who gets the meal delivered faster? Which restaurant charges more? Which generates a higher perceived value? Those are all questions we will evaluate in detail in this book.

In the following chapters, you will learn how to identify your market, analyze effective forms of advertising, create advantageous digital portrait programs, evaluate digital session techniques, sell digital products for a profit—and bring balance into your life!

Sometimes, expediting your workflow too much can backfire!

No matter which viewing timeline the studio or client prefers, the digital process allows clients to receive their finished product within six to eight weeks from their final session. Image by Sherri Ebert.

1. IDENTIFY YOUR MARKET

Before spending countless advertising dollars on direct mail, e-commerce, and mall displays, it is important to identify your studio's niche and target market. This will save you a lot of time and money. What type of product do you want to create: hand-colored portraits, oils, black & white custom prints, or computer-manipulated images? Who are you trying to appeal to, and what type of product would most likely attract them? In order to allocate your finances in the best possible manner, it is important to have clearly defined goals, to identify your primary market, and to evaluate your product's features or benefits.

Create a look and then reproduce it consistently in every session. The subjects and the pose may change, but the style should remain consistent. Image by Kay Eskridge.

■ FINDING YOUR NICHE

The first step to effective marketing is to identify the product you want to produce and determine your target demographic. Next, you'll need to decide whether or not your intended product will be in high enough demand to sustain your business. You should aim to create a niche in your market and produce images that distinguish you from other photographers in the market. Offering something unique can make a big difference in helping your business grow. For instance, by creating *art* instead of just photographs, you increase your client's perceived value of your product and services.

Digital technology provides endless opportunities to establish a signature style. With the popularity of today's image-editing software, you can easily choose a tool or plug-in to consistently produce a look that epitomizes your unique image style. Understand that, no matter the style you choose, it is important to find your niche and produce that style of work consistently. For example, if you produce a sepia image with a vignette, then every session you conduct should have a minimum of one of those images. Once you build your studio's reputation, people will flock to your studio for that original art piece and will eventually buy more standard work as well, thus increasing your visibility in the community and building your profits!

After you identify the type of product you wish to create, the next step is to determine the type of clients you want to attract to your business. Your first instinct may be to go after as many different types of

There are many different styles of children's portraiture—classic, contemporary, environmental, artist rendered, and much more. Above image by Frank Donnino. Facing page image by Sherri Ebert.

Sheridan Elizabeth
-3 months-

clients as possible. However, by doing this you will never appeal to any one group, and you may possibly turn potential customers off. Your promotions will be more cost effective if you target just one type of customer.

As mentioned earlier, if you're just starting out in the business, you must determine which type of client will help you to achieve your creative and financial goals. If you run an established studio, the following questions will help you to fine-tune your marketing strategies.

- Are your clients young or old, single or married, men or women?
- Do they have a specific income level or educational status?
- What zip codes do they live it?
- Where do they shop?
- Do they belong to clubs, organizations, schools, or churches?
- Do they have shared attitudes, beliefs, or emotions?

Without a true understanding of who your clients are, you are simply gambling with your marketing dollars. It is important to take the time to identify any common characteristics of your market. If you identify the type of client you are searching for, then you can employ strategies used by the nation's leading businesses to attract them. Perhaps you are trying to be everything to everyone. If that's the case, you may be missing the boat in all markets. Even if you want to appeal to more than one market, it is important to make certain your marketing approach changes as your market does.

Finding a unique approached that appeals to your target market is the key to succeeding in portrait photography. Top image by Maring Lifestyle Photography. Above image by Vicki Popwell. Facing page image by Gregory Daniel.

■ APPEALING TO YOUR MARKET

So you know what you want to do and have identified the right market, but have you determined what those clients want from you? Most successful business owners analyze their target demographic then evaluate their prospective client's attitudes, beliefs, and emotions to create a promotional campaign that appeals to them. There are five main characteristics the average client seeks in a quality portrait studio: appearance, qualifications, communication skills, dependability, and critical thinking skills. Let's look at each attribute in detail.

Appearance. The impact that your studio's appearance has on a prospective client will either compel them to investigate your services or will drive them away. Appearance is based on much more than your artwork; your website, business cards, studio, employees, and your personal appearance speak volumes to your clients! For instance, if a client wants to hire a celebrity photographer, then they'll look for a studio that's more upscale. A client who wants a more traditional family portrait can, in judging the studio's atmosphere and publications,

Jeff Hawkins believes creating an atmosphere that is attractive and welcoming to your clientele is a key element to making them feel at home and keeping them coming back. Photo by Jeff Hawkins.

Make sure that your studio has a professional appearance. Photograph by Hayes and Fisk—The Art of Photography.

determine that a comfortable, down-home, family-friendly studio is right for them. What type of message do you want your studio, website, and print materials to communicate? To whom do you want your studio to appeal?

Low Budget/High Volume. This type of studio appeals to individuals and families who might be intimidated by an expensive, high-end studio. If this is the demographic that you want to target, evaluate the advertising strategies employed by businesses that attract this type of client. Major retail establishments spend lots of money researching and analyzing where and how their advertising dollars are spent. If your clients tend to shop at discount stores, eat at family restaurants, and get most of their family portraits taken at high-volume studios (like the ones in department stores), then evaluate those businesses' websites, print materials, and locations to see how yours compares. If you discover some similarities, then you are probably on the right track.

Many people feel quite comfortable in selecting this type of studio because it has a retail-like appearance. Typically, the costs are better aligned with their budget and the environment is not as intimidating.

There is no right or wrong market to pursue; there is a market for every business. The key factor is knowing who you want to reach and how to reach them.

Most clients care more about getting lots of images to share with family and friends than about the type of image they are getting. If you have a fancy website with lots of flash, you might lose some of your market, because some of your visitors may not have modems or computer systems that can keep up with your technology. Likewise, if your place of business or your mall display is very upscale, some clients might assume they can't afford your services and may never make the inquiry.

Low Volume/High Budget. On the opposite side of the spectrum, you have the studio that strives to appeal to a higher-end client. To these people, fine dining, designer clothes, and luxury vehicles usually seem appealing. These clients care more about getting a one-of-a-kind fine-art piece than a typical family portrait session. With these clients, the appearance of your studio, your staff, and your artwork will make or break the sale. Visit the websites of some of the top clothing designers and frequent major department stores and other high-end retail establishments. Have you created that same branding with your target market?

Qualifications. Before committing to a studio, clients also want to be certain that a photographer is qualified to produce the kind of images they need. Most business owners can advertise or talk until they are blue in the face, and nothing they say or do will validate their

Make sure your marketing materials reflect the quality of your studio and your work. Photographs by Hayes and Fisk—The Art of Photography.

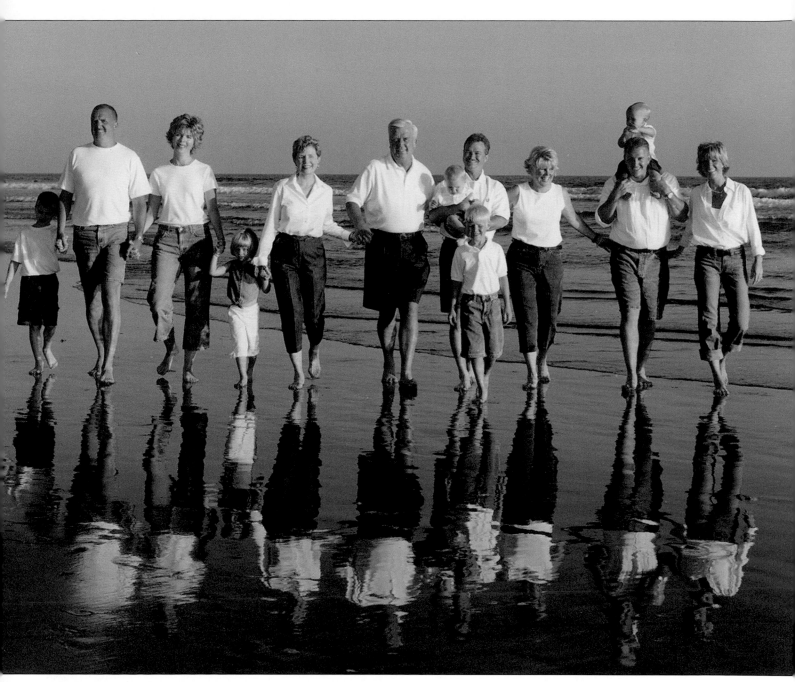

Once you build your clients' trust in your studio, you can count on their loyalty for generations to come. Photo by Kay Eskridge.

skills. Their reputation in the industry speaks volumes about their abilities and, in the client's mind, referrals from friends and family members are good indicators of their ultimate satisfaction with that studio. Keep in mind that *word-of-mouth* advertising is the number-one means of capturing your market.

Communication Skills. The next important characteristic a client evaluates in selecting a studio is the studio's ability to communicate. Keep in mind that clients evaluate not only the way the owner communicates, but also critique the studio's website, written correspon-

GET TO KNOW YOUR CLIENTS

Consider the following ideas, which will help you to build deeper relationships with your clients and aid in identifying their wants and needs.

- Place a small locked suggestion box in your studio. It is a simple way to get feedback from your clients about your services and the overall studio experience. When they are too disappointed about some aspect of their experience to say it to your face, they may be likely to write it down.
- When delivering or sending invoices, include a questionnaire and self-addressed, stamped envelope. (Preprinted survey cards can be purchased from a number of suppliers.)
- Contact a leading publication (for instance, a bridal magazine or a parenting magazine) and request a media kit. Included in the materials will likely be a breakdown of the demographics of their readership. This can help you to better understand the demographics of your target market.
- Many industry leaders and organizations offer marketing and/or business training and assistance to the photographic industry. These may prove to be a valuable resource for continuously improving and updating your marketing and business skills.

dence, and—most importantly—the staff and receptionist answering the phone! I've come across a mind-boggling assortment of misspelled words in photographers' websites, poor grammar in mailers and other printed materials, and unprofessional answering machine messages. It doesn't matter how incredible your work may be, you can miss out on a million-dollar opportunity because of poor communication skills.

Dependability. Dependability is the fourth characteristic clients are looking for in a successful portrait photographer. Good, consistent photography and great customer service will keep clients loyal for a lifetime. It is important to win your clients' trust and keep them coming back. It is much harder and costs much more to gain a new customer than to bring an old one back!

Critical Thinking Skills. In gaining the business of the market you are pursuing, you'll need to convince the prospective client that your studio's operations are based on adept critical thinking skills. Critical thinking skills are used to spot assumptions, separate fact from opinion, and see things from more than one angle. Imagine a new photographer who hasn't yet honed in on the importance of these skills!

You can miss a million-dollar opportunity because of poor communication skills.

They might well have trouble handling a young child who is being uncooperative, a family portrait session with a larger amount of people than anticipated and nowhere to pose them, difficult lighting situations, technical difficulties, or equipment failure. How the photographer responds to these scenarios will keep his or her clients coming back—or will send them running.

Once you have created a unique product that appeals to the segment of the market you'll be targeting, you can begin honing your marketing strategies to ensure you're sending the correct message to your prospective clients. Remember to follow the example of some of the nation's leading retailers. By fine-tuning the five criteria outlined above, you'll make optimal use of your advertising budget and ensure increased profits! However, it's worth noting again that change is important: your marketing plan should be reviewed and adjusted annually.

> **Your marketing plan should be reviewed and adjusted annually.**

■ EDUCATION

There are a wide variety of courses available to eager professionals, no matter where they live. Many industry leaders and organizations offer training sessions on important topics such as marketing and business basics. We have listed a few of the most commonly referenced ones below. These may prove to be a valuable resource for continuously improving and updating your marketing and business efforts.

- **Wedding and Portrait Photographers International** (WPPI) holds a yearly convention that's chock-full of seminars on every aspect of the photography business, including marketing and business basics. Be sure to inquire about their publication, *Rangefinder,* also. Visit www.wppinow.com or call 310-451-0990.
- **Professional Photographers of America** (PPA) hosts a national convention as well as state and regional seminars and weeklong schools to help promote and encourage business education to their members. Visit www.ppa.com or call 1-800-786-6277.
- **Marathon Press** conducts a two-day, hands-on marketing workshop that lets you create a marketing plan, meet with designers, and leave with ideas and marketing pieces ready to put to advertising use! Visit www.marathon press.com or call 1-800-228-0629.

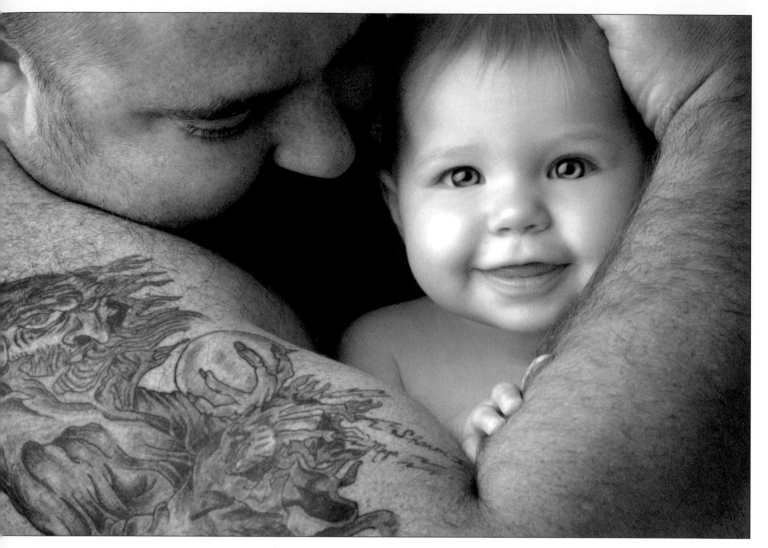

- *PhotoVision*, a DVD magazine, provides you with monthly training and insight from the nation's leading studio owners and photographers. Visit www.photovisionvideo.com or call 1-888-880-1441.

Feedback and advice from other professionals can improve your images and your business. Photo by Jamie Hayes.

A great advantage of delving into industry education is meeting different photographers within the industry. Some of the best advice, most helpful ideas, and premier networking opportunities will come out of contacts gained from the resources above. These relationships will provide a valuable source for referrals, ideas, and mentorship.

2. REFERRAL PROGRAMS AND PROMOTIONS

It costs a company twice as much to get a new client as it does to retain an old one

It costs a company twice as much to get a new client as it does to retain an old one, so why is it that studios continue to market only to new clients and forget about the existing ones? Most of the photographers featured in this book stated that 90 percent of their business comes from referrals. They spend very little money advertising to new clients. For instance, Charles Maring of Maring Lifestyle Photography, which has a studio both in Connecticut and New York, stated, "There is no doubt that referrals go a long way and that our business is based on referrals. We don't do a whole lot proactively to build our business, but we keep the clients we have happy, which in turn builds new business." That statement is very accurate. If you take the time to discuss with the client what they envision and then provide a service that meets or exceeds their expectations, they will not only use your services in the future but will continue to recommend you time and time again.

There are several ways to increase your studio's perceived value and encourage repeat business or referrals. Among these strategies are

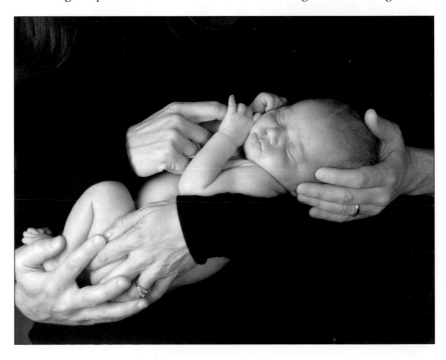

Kay Eskridge describes her Watch Me Grow program (see next page) as a win/win situation for everyone. Image by Kay Eskridge.

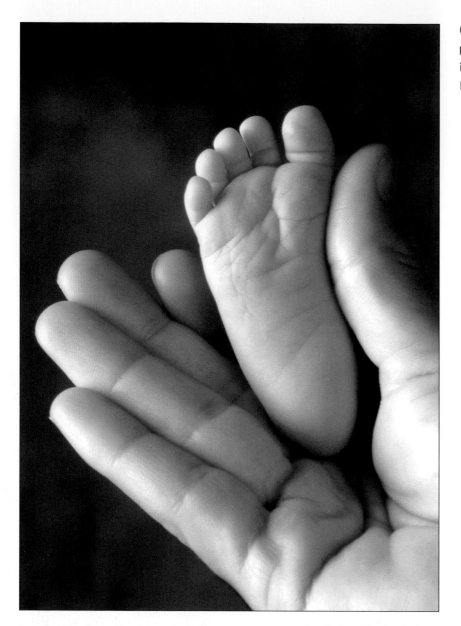

Capturing every little detail of the client's precious newborn surely showcases the infant as the tiny treasure he or she is. Photo by Kay Eskridge.

implementing client-appreciation programs and offering limited-time special offers. We'll look at these options below.

First, implementing and marketing a client-appreciation program is an easy and cost-effective way to keep clients coming back. These programs offer customized incentives for specific consumer groups (as opposed to mass marketing via a database where everyone would get the same promotion). Though there are many different kinds of such programs, a description of some of the most successful follows.

■ WATCH ME GROW

Kay Eskridge of Images by Kay & Co. in Phoenix, AZ, offers a program that, much like a frequent-flier program, rewards clients who return to

her studio year after year. First, the clients sign a contract guaranteeing they will have Kay's studio photograph their child at least once a year. They prepay for a "builder" album that grows as the child does, they receive discounts on session fees and print orders, and are notified in advance of all special programs offered throughout the year. Should they break the contract by not coming in for their annual session, the album is still theirs but the studio no longer offer the discounts or bonuses. It's still a win/win concept for both. This program is especially beneficial for families with more than one child, because each child, as well as the parent, needs an album.

According to Charles Maring, "There is no doubt that referrals go a long way and that our business is based on referrals." Photo by Maring Lifestyle Photography.

■ LITTLE WONDERS

Another of Kay's preferred programs is called Little Wonders. The images are usually captured in color and converted to black & white and can be placed in a wall collage or different size albums or image

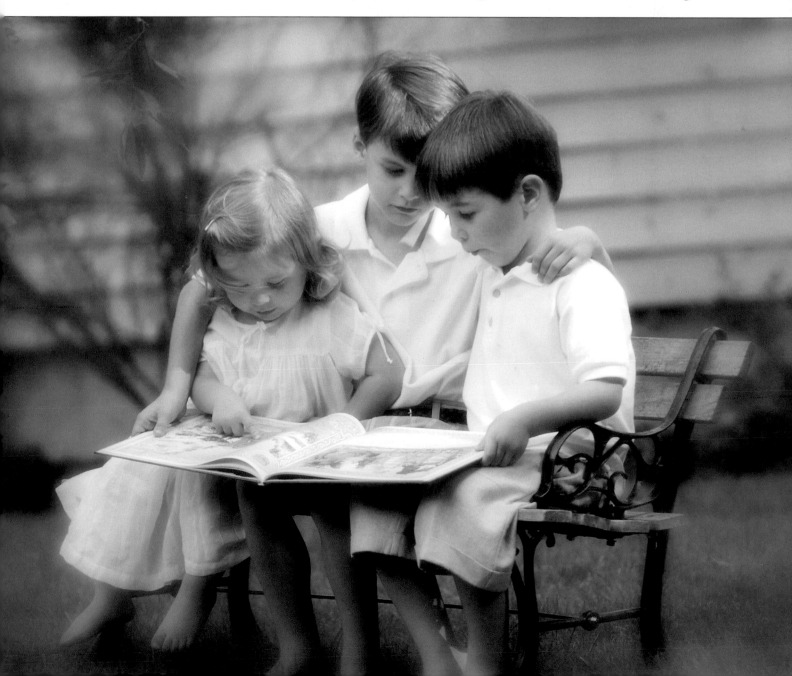

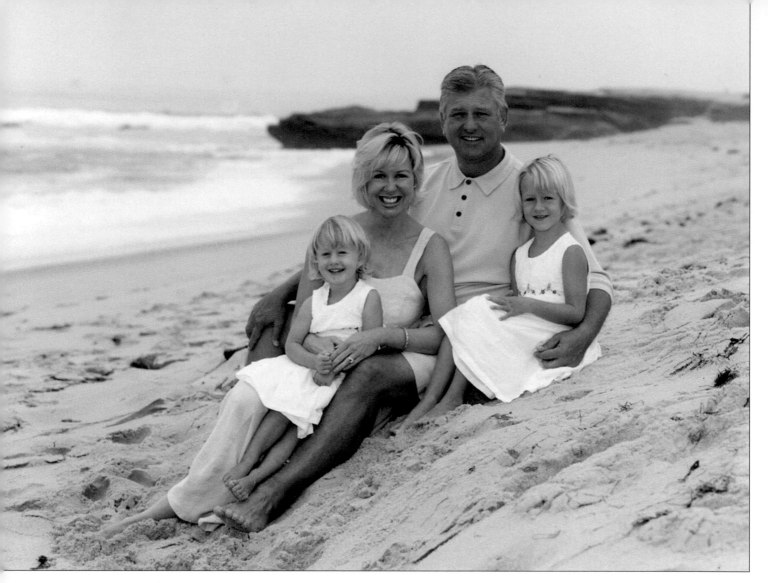

boxes. Says Kay, "We focus on all the special little parts of a baby that make them the miracle they are. This program can be taken advantage of as soon as the baby is born, up to one year after the birth. This is also a great way to incorporate parents or other siblings. These are relationship images and capture a time in a baby's life that will change so quickly. This is our favorite program."

Summer vacation and getaway sessions are a fantastic way to write off summer trips and balance business with pleasure. Photograph by Kay Eskridge.

■ SUMMER VACATION PORTRAIT EXPERIENCE

This is yet another great idea that comes from Kay Eskridge's studio. Says Kay, "Each summer we travel to the places where our clients spend their summer vacations. We spend four weeks photographing Arizona families enjoying the sun and sand of the beaches of Southern California and two weeks in the mountains, pines, and streams of Northern Arizona. This is an amazing opportunity for our clients and a nice way to write off our summer trips. We do mix a little business with pleasure while we're there and make money while doing it."

Jeff Hawkins, of Jeff Hawkins Photography, located in Central Florida, has developed a similar program that's been very successful. The details of the program follow.

■ GETAWAY SESSIONS

Photographer Jeff Hawkins has found a money-making way to mix business with pleasure: the getaway session. As you'll see, this session type is a notch above a trip to a local park. Says Jeff, "We've found that we would sell more when conducting a session on location (e.g., tourist attraction, beach, historic park, or garden). However, because most of these locations are forty-five minutes to two hours away, we had to compensate for our travel time. We tried implementing both minimum product purchases and higher session or travel fees and found it only discouraged the session. By discouraging the session, we were hindering our sales. Instead, by offering getaway sessions, clients can take advantage of on-location sessions with no additional session fee or travel charge. We simply pick a location and promote the session several weeks in advance. The first ten families (or whatever amount we elect to do based on how much business we want to incorporate or how much we want a vacation) that sign up get to take advantage of the special offer. We hold each session back to back and schedule them approximately forty-five minutes apart. We stress to the families the importance of arriving early and even ask them to bring a friend or another family along at the same time—with no additional charge! (This builds referrals.) Typically, getaway sessions are held once a quarter over a weekend. We hold

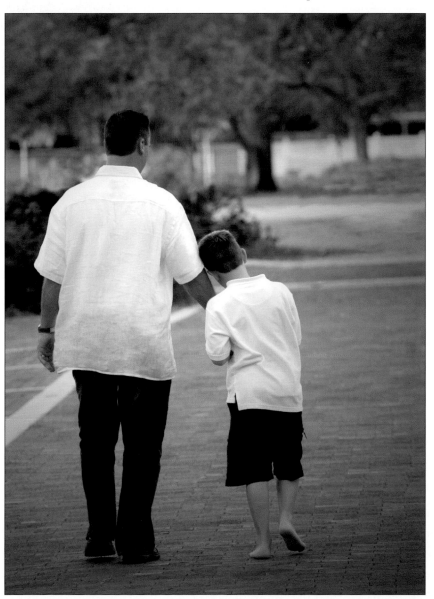

Jeff Hawkins explains, "Getaway sessions are a terrific way to increase your portrait sales and build your customer database." Photo by Jeff Hawkins.

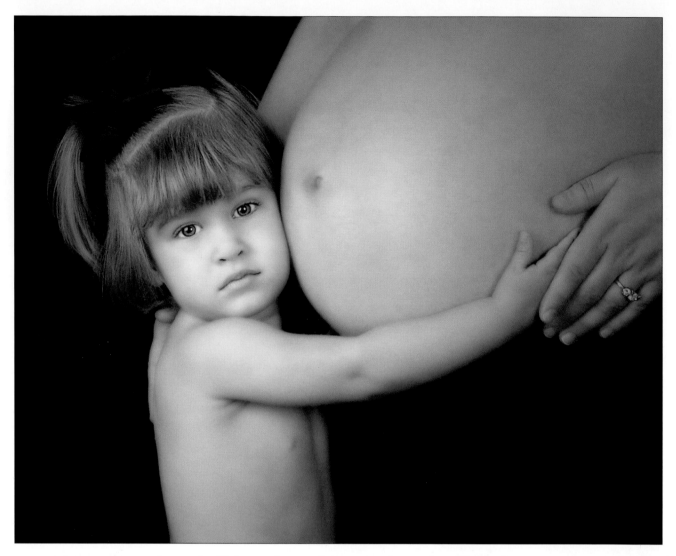

two to four sessions a day and still have plenty of time to relax and enjoy a mini vacation."

Lifetime Portrait program members can come back to the studio as often as they like to receive a complimentary portrait session. Photo by Kathleen Hawkins.

■ LIFETIME PORTRAIT PROGRAM

Another program offered by Jeff Hawkins Photography is the Lifetime Portrait program. The program, which provides customers with an incentive to keep coming back to the studio, has helped the studio develop a repeat customer base and has created new and interesting portrait opportunities.

How it Works. Lifetime Portrait program members can come back to the studio as often as they like to receive a complimentary portrait session (portrait dates, times, and locations are subject to availability). Depending on the type of portrait requested, the number of people being photographed, and the desired location, a minimum product purchase may be required. This program plants the seed that we want

to be the client's photographer for a lifetime. (So, what constitutes a *lifetime?* A statement on the back of the client's membership card reads, "The Lifetime Portrait program is valid for the rest of your life or ours, whichever lasts longer!")

A photographer looking to grow their portrait business can use the Lifetime Portrait program as an incentive or bonus for their wedding clients, commercial clients, or business clients. The program may be purchased by new clients for $1450, though Jeff has occasionally offered memberships for as little as $500. (This is typically done when Jeff wants to buy a new piece of equipment!)

■ SPECIAL OFFERS

Limited-time special offers increase traffic and client commitment. Consider the following limited-time special offers as ways to build your clientele or encourage repeat appointments from current clients.

- **Tap into the potential of themed portraits.** You're limited only by your imagination here. For spring, try a baby and

Limited-time special offers increase traffic and client commitment.

From wedding and maternity images through photos that chronicle the life of the family, the Lifetime Portrait program keeps clients coming back. Photo by Kathleen Hawkins.

bunny portrait. In winter, try a Christmas theme. Of course, there are many other options as well. Fairy portraits and Teddy and me portraits are client-pleasers as well. Photographer Kay Eskridge discussed her success with a promotion offered for Mother's Day/Father's Day. She explains, "This program is a great opportunity for one parent to surprise the other with images of themselves and the children. We have found the majority of our clients like relationship-style imagery in black & white, and that's how we handle it for this program. Wall collages for offices and mini albums for the home are big sellers with these sessions."

- **Consider offering a client-appreciation discount once a year.** Reward your best clients with a special offer for conducting their holiday family portraits in July and ordering their holiday cards early!
- **Consider holding a raffle for a portrait session at a local restaurant.** Be certain to have one of your portraits on display!
- **Start a birthday and/or anniversary club.** Track your promotions with Marathon Press's Client Connection program.
- **Send out a calendar with special events and/or promotions.** Also consider listing the events on your website.

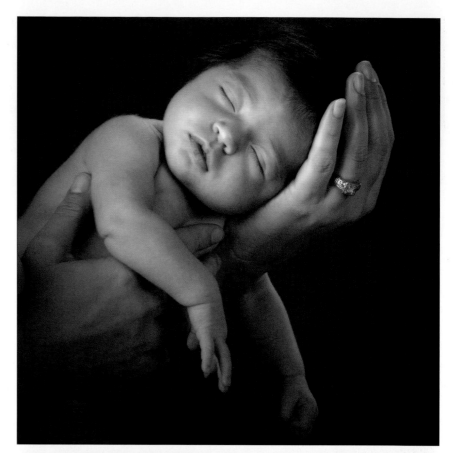

Special offers increase traffic and client commitment. Top photo by Kathleen Hawkins. Bottom photo by Gregory Daniel.

Kay Eskridge's black & white "relationship" wall collages are big sellers. Photo by Kay Eskridge.

LEFT—Creating themed promotions will keep your clients committed and excited about their next portrait session. Photo by Mary Fisk-Taylor. **RIGHT**—Mother's Day or Father's Day portraits make great gifts for the other parent! Image by Kay Eskridge.

- **Conduct a fund-raiser with a local charity.** This is a way to increase traffic and get free publicity!
- **Be a guest speaker at a local Chamber of Commerce meeting, bookstore, coffee shop, or women's club.** Discuss the benefits and importance of creating a family heirloom.
- **Got a well-known client or know someone who knows a VIP?** Use your connections. Photograph a well-known person and get their permission to showcase their image.
- **Create a Baby of the Month program and promote the winners on your website.** The proud mom will help draw traffic to your site, indirectly creating referrals. (Caution: be sure to obtain model releases for all your winners before displaying their images online!)

Never forget that many other studios are vying for your customers' business. Once you lose customers, it is hard to win them back. Few

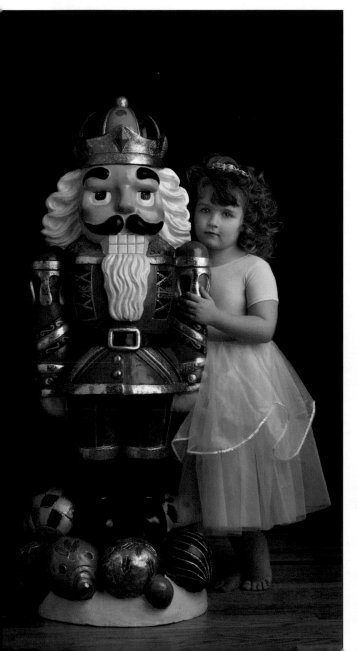

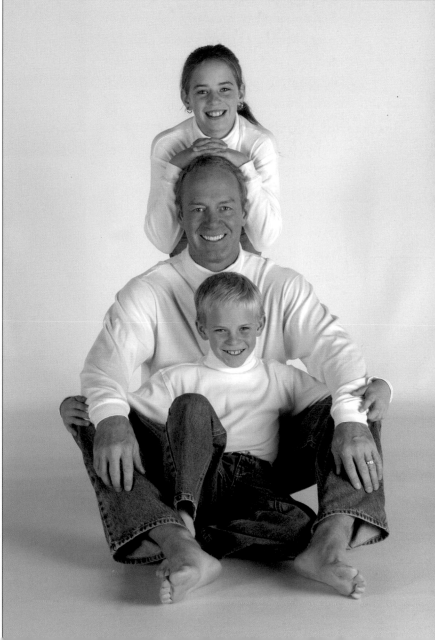

will tell you they are unhappy, they will simply buy from someone else.

■ THE NEXT CHAPTER

Now that you have carefully determined the needs and wants of your prospective and existing clients, have come to understand the value of customer service, continuing education, and the reevaluation of your marketing strategies, and have implemented or devised a strong client-reward program, it's time to create a strong business identity. This topic will be covered in detail in the following chapter.

Before we move on to the next chapter, though, it's important to understand that there are two things about your business that should *not* be changed when you evaluate your marketing strategies: your name and logo. No matter where you are in terms of your marketing, selecting a new name or logo can confuse existing clients and result in decreased sales. Don't give up on existing clients as you seek to define your target audience. Your marketing endeavors should begin with your existing client base but should be expanded to attract prospective clients as well.

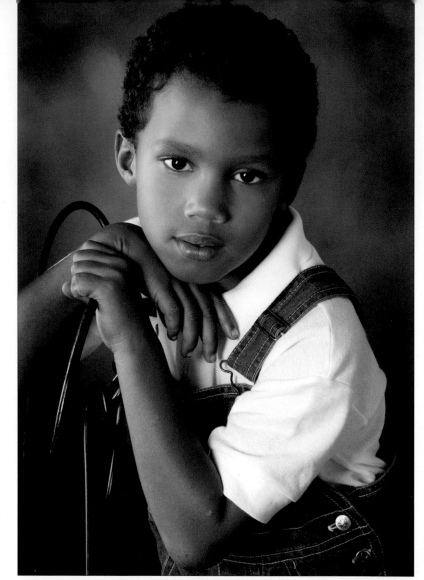

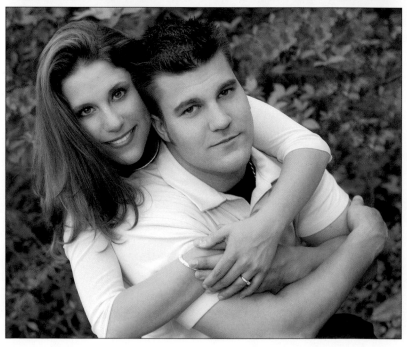

Don't give up on existing clients as you seek to define your target audience. Photographs by Sherri Ebert.

3. ADVERTISING AWARENESS

*W*hile selecting a business name and logo are important, it's just a small part of launching your advertising campaign. Creating synergy in your marketing is also vital to début a look that is unique yet memorable to your audience. The more you get wrapped up in the mission of your studio, the easier it is to desensitize yourself from the day-to-day tasks and effectiveness of your promotional pieces. We have a tendency of getting so busy we forget the fundamental elements that make for good promotions. A postcard may look good on its own, but is there synergy with your other marketing materials? You may be emotionally attached to a specific print because it was your only portrait that made it to the PPA Loan Collection; but five years later, does it still represent your work?

In this chapter, we will examine the key elements to attracting new clients for a lifetime. These elements include: website creation, direct

A VALUABLE REMINDER

While I was doing research for this book and consulting with studio owners from across the nation, I found a valuable but seemingly unlikely ally—and learned a very valuable lesson.

I'd been approached time and time again by Marathon Press in regards to attending one of their marketing programs, using their services, or joining their VIP program. I assumed their services were too expensive and that I was too educated to benefit from what they could offer our studio. However, I reluctantly attended a workshop just to better educate myself on the products and services that were available to the industry. I went to this two-day workshop with my arms crossed and the attitude that I would never learn anything! (Keep in mind that I hold an MBA, minored in marketing, and taught 1000- and 2000-level business/marketing courses at a Florida university for several years.)

By the end of the first day, I was amazed! I quickly realized that in meeting all of the demands of our fast-paced studio, I had begun to lose sight of the bigger picture. Instead of creating a great, cohesive series of mailers and a unified marketing approach, I was focused on the details. (In this chapter, you'll see examples of the marketing pieces we used to use and the ones we began to create following Marathon's marketing program. As you peruse them, note the consistencies among our new materials.)

In the end, what I assumed would cost too much money has actually saved us money! Our studio now has an independent contractor on staff (through Marathon Press) who designs, prints, and mails what we want, when we want it—at a very affordable price.

mail promotions, and business displays. Now, we will review the strategies for making these elements successful and combining the efforts to produce a high level of synergy!

■ WEBSITE DESIGN AND E-COMMERCE

One of the best and most cost-effective ways to advertise your business is to optimize your company's Internet presence. A quick review of the five studio-selection criteria outlined in chapter 1 will help you to analyze your client's needs and determine how to meet them. The following do's and don'ts will help you to create a user-friendly presence on the World Wide Web.

- **Just because you can, doesn't mean you should!** Avoid using Flash or JavaScript. Until you are certain that your entire audience can view the site, using it could be costly. Sure, it may be fancy and it may be cool, but if it limits your audience, it will cost your studio money! If you feel you *must* use some Flash on your site, analyze where it should be used and how effective it will be in getting your message across. There are dozens of studio websites that waste their clients' valuable time just to "Flash up" the studio's name. Ask yourself, is that an effective form of advertising or a waste of your client's time? Remember, it's all about the customer, not about you. Images, emotions, and music move your audience to continue browsing your site, but fancy effects won't.

- **Remember who your client is!** You (or your designer) may be a techie, but your client may not. Consider the majority of your market and design a site that will appeal to the average viewer. Put yourself in your prospective client's place! Remember the importance of seeking out the websites of the places in which your clients are most likely to shop. If most of the high-end fashion retailers, perfume, or jewelry websites don't have a black background on their site, should you? If you are a male photographer but the majority of your customers are women, are you appealing to a female market, or are you showcasing what appeals to you? Analyze who the majority of your customers are and then design a site that specifically appeals to them.

- **The first impression is worth millions!** On an average, your client will form eleven different opinions about your busi-

Is that an effective form of advertising or a waste of your client's time?

E-MAIL CORRESPONDENCE

To make the most of e-commerce, be sure to use personalized e-letters and e-newsletters when communicating with your client base and answering prospective clients' requests. Use the copy-and-paste system as a time saver, but always remember to personalize your e-mail to potential clients. Samples of standard e-mail responses are included in appendix 2 of this book.

The more prevalent spam becomes, the less consumers will be receptive to e-mail promotions. In response, businesses will rely on the direct-mail standard that has brought them success for many years, thus using promotional pieces to draw traffic to their website and increasing the effectiveness of their advertising dollars.

Make initiating contact with your company easy for prospective clients.

ness within the first thirty seconds of viewing your site. Make sure the first thirty seconds count! Be certain to showcase something to appeal to each of your markets at once. For instance, if you are marketing maternity, children's, and senior photography, provide something that's related to each market within the first thirty seconds. This will subliminally create cross-marketing for your studio. If you provide online ordering options to your clients and ensure that each type of photography you specialize in is represented in the first thirty seconds, you may be able to cross-market to a new segment. In other words, if a bridal client sees your children's portraits on your website when she places her order, then she may eventually hire you as a family photographer, too.

- **Make your site easy to navigate!** Always make a clear path for the viewer to find their way home (your home)! Don't let your viewer get lost in your site. This could lead to frustration and cause them to exit before their voyage is complete. You spend advertising dollars and time drawing traffic to the site—don't lose potential clients once they are there!

- **Remember, some people use the Internet to find contact information.** Feature your phone number, mailing address, and e-mail address on every page, and make them easy to find! Never rely on a web presence alone to make your phone ring. Make sure that your contact information appears on all of your printed marketing pieces as well. Eighty-five percent of your web traffic will be made up of prospective clients who found your web address listed on a traditional promotional piece, display, or business card.

- **Make initiating contact with your company easy for prospective clients.** While having clients fill out an online

form to contact you will provide some valuable information, be sure to allow direct e-mail as well. Often, a returning customer with a question won't want to take the time to make a phone call or complete an entire request form. The more obstacles you put in front of your clients, the more likely they will be to move on to something more convenient.

- **Show what you sell!** Place your products online, but don't replace the personal follow up. Give your clients enough information to create the opportunity to close over the phone. Don't place all your pricing information online, just present basic information and photographic examples of product options. This will permit phone interviews, booking clients at a distance, and taking retainers or minimum product credits over the phone, thus allowing you to work out the remaining details during a studio consultation.

- **Avoid links!** You spend lots of money sending people to your site, and links only send them away! Negotiate with other vendors (clubs, churches, etc.) to provide stock photography in exchange for a link. This will add you to their site without having to reciprocate. The joys of digital photography will permit you to provide stock photography at a minimal cost. This is a great advertising benefit for you.

- **Close the deal now!** There was a time when the marketing rule was to bring your client into the sales room so they could see, touch, and smell the product—and make an emotional buy. Times have changed. People are busy and, with the use of the Internet, sales can be conducted over the phone.

- **Back up your data!** Save your site on a DVD or other storage medium. Don't rely on the person or company currently hosting your site to keep it up. If something were to happen to sever that relationship, your site would be out of commission. A website down is just like a phone line disconnected. Time is money, and every minute counts!

- **Keep it fresh!** It is amazing how many photography studios' websites are filled with words instead of images. This is a visual world! Avoid excessive wording and keep your images up to date (make an appointment to update your site and write it on your calender to avoid procrastination). Get input on your site from one of your employees, a family member,

Place your products online, but don't replace the personal follow up.

or friend. This will prevent you from utilizing an image just because you are fond of the subject.

- **Optimize your search engines.** Just because you can do a little web configuration, doesn't mean you should. It is essential to understand search engines and the importance of keyword phrases. However, you should leave the behind-the-scenes tweaking to an expert. Know enough to know how to read your competitor's source codes and then hire a pro to keep your source codes and key-word phrases current.

Now that you have acquired a basic understanding of what makes a good website, be certain to include the following components on yours:

- **Home Page.** Ensure this is easy to access.
- **Portfolio Page.** Limit the number of images you include for optimal use. Break images into different segments or categories so that the pages load faster. Add additional pages if required.
- **Contact Page.** Use the contact form to give you the essential information on your prospective client—and his or her referral source.
- **Information Page.** Indicate what makes your studio unique. Also ensure that this page contains your studio's name and slogan, plus any pertinent general information, professional associations, and a professional bio.
- **Map.** Provide a map to your studio.
- **Hours of Operation.** Be sure that your hours are clearly listed on your website.
- **Special Promotions.** Add a newsletter or image-of-the-month promotion. Changing your site frequently will encourage people to revisit it in the near future, thus keeping all leads and prospects active.

Changing your site frequently will encourage people to revisit it in the near future.

■ DIRECT MAIL

When you are creating a promotional mailer for your studio, the first consideration is whether it should be an image-marketing or action-marketing piece.

An image marketing piece is a promotional mailer about your studio that shows what makes your studio different. This type of mailing

THEN . . .

After attending a very helpful marketing seminar, I realized that I had been overlooking the big picture when it came to our marketing materials: they did not have a consistent message and look.

Our old website design.

A sample of an old postcard design used by our studio.

NOW . . .

What a difference! Once we began to pay attention to the big picture, we were able to make a more powerful statement with our marketing. Notice how the logo is consistent throughout these samples. We use the same fonts and colors, too, building a sense of continuity. Because everything is coordinated, our message is communicated effectively to prospective clients.

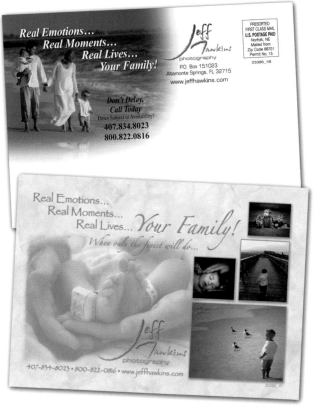

Our current website design (above) and postcard designs are now coordinated in their color, design, and message.

will most likely include an image example of your unique work and will list your studio name, logo, slogan, and contact information. Remember, prospective clients typically have to see your name three times in order to initiate a response. Image marketing pieces will help to generate that response.

An action marketing piece is a promotional mailer that inspires a call to action. They contain slogans like "Act now to receive 50 percent off holiday portrait packages" or "Buy 1, get 1 free," or "Get 2 sessions for the price of 1!" that urge the client to act in order to take advantage of your offer.

Once you understand the intention of the direct mail piece, take into consideration the following tips:

- **The goal of a direct mail piece is to grab the prospective client's attention.** This can be done with a catchy title, a powerful image, or a bold color. Make sure one dominant feature jumps off the page. Don't overemphasize too many items. Think back to high school. Do you remember using a highlighter to mark the important passages in a book? If you were overzealous, before you knew it, you'd end up with a big yellow page and defeat the purpose of highlighting to begin with. The same theory applies here as well.
- **Keep it simple and don't be wordy!** Leave plenty of white space to make your message easier to read. Design your message as if every word cost money! Columns should not be too wide or too small, and paragraphs should be short bullets or bold titles. Stick to one or two fonts per direct mail piece. (Your logo can be counted separately.)
- **Use both sides of the card.** Side one should grab the potential client's attention and side two should motivate the response. For an effective response card, you should have an obvious call to action and a clearly visible logo.
- **Consider how your postcard can serve a dual purpose.** Use it as special gift to VIP customers, a ticket to an event, or perhaps as a gift certificate. A dual-purpose mailing sparks a faster reaction from the prospective client.
- **Consider the timing.** If you are mailing to households with children, the week before school starts may not be the best time to send them a postcard. Parents are overwhelmed with other activities, and your piece will get lost in the shuffle.

For an effective response card, you should have an obvious call to action and a clearly visible logo.

- **Use illustrations that flow with your message, not just images you are partial to.** In other words, consider the message when selecting the images.
- **Be sure to track your results.** Utilizing studio management software will help optimize your marketing systems and provide you with accurate results, cost ratios, and figures. (See chapters 4 and 10 for information on this software.)
- **Use Marathon's Client Connection software and marketing partnership service (www.marathonpress.com) for postcard mailings and building client relations.** This software will make preparing, printing, and sending your mailers easy and cost effective. Prior to using this service, we designed our postcards in-house, paid a couple hundred dollars for four-color printing, then paid an hourly employee to label, stamp, and mail the postcards. Now, we can click on the card we would like to use, upload or select an existing database, and click-process for pennies a card! Marathon prints, labels, stamps, and mails the postcards for less than the cost of our old postcards alone!

Utilizing studio management software will help optimize your marketing systems.

■ BUSINESS DISPLAYS

Another fabulous way to increase your client base is with the use of business displays. However, before you begin your journey to reveal the most prominent businesses in which to display your work, know what you are willing to do in exchange for the display. Be sure, too, that you've allocated a portion of your marketing budget for the creation of high-quality displays.

Continuity and Purpose. When establishing display criteria, it is important to extend the synergy from your studio design and décor through your marketing pieces and your displays. Be sure to include your finest work, make sure it is well suited to your preferred client, and invest in quality frames for those images.

Also, don't lose sight of the big picture. Your goal is to target your ideal client, and in order to do that, you must ensure that your display reflects your business goals. Jamie Hayes of Hayes & Fisk—The Art of Photography, in Richmond, Virginia says, "Our goal is to create beautiful wall portraits. All of our marketing and displays further support this goal. We display large hand-painted Brush Oil [Essentially, brush strokes are applied to a digital portrait. The colors in the image remain the same but an oil-painting texture is introduced to simulate a paint-

MODEL RELEASES

Be sure to have signed model releases for anyone whose image will be displayed. This is especially crucial when displaying a portrait of a child.

ed portrait] and canvas portraits in Strasburg Children stores and all of our mall displays. We display our work in three malls, and the displays bring continued success."

It is also important to determine the best locations for your displays. To begin with, brainstorm to come up with a list of area vendors whom your prospective clients may visit frequently. Consider referencing local children's magazines for referrals. Other locations to consider may include local malls, children's clothing stores, Parade of Home

Frank Donnino bartered out his wall display with a local mall.

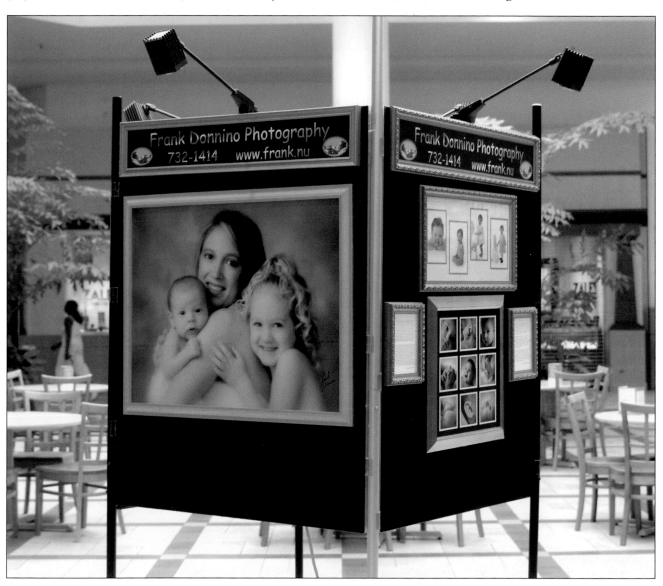

events, doctors' offices, dance schools, banks, Junior League associations, women's clubs, libraries, etc. Next, select the areas that have the highest amount of traffic in relation to the investment required. Determine if you can reach a deal with the establishment to provide free photography in exchange for the display space. Barter whatever you can whenever possible. With digital technology, your costs can be minimal (just the time spent on the session), and you can save a lot of money on monthly rental fees.

Be sure to follow the basic design guidelines outlined earlier when creating your display and selecting any promotional pieces that will accompany it. Remember, your logo and contact information should be visible and easy to read! Check your display frequently to be certain it still maintains the integrity you want it to uphold and to see that the cards are replenished. Keep your décor simple and elegant. Often less is best. The number of display images will be determined by the amount of space you have to work with. Be cautious not to be overzealous; too many images will only make the

The proprietors of Hayes & Fisk—The Art of Photography believe in the power of mall displays and have several locations. Photographs by Hayes & Fisk—The Art of Photography.

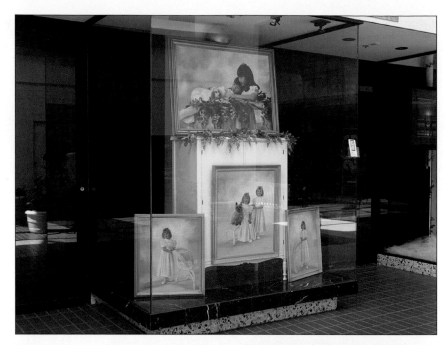

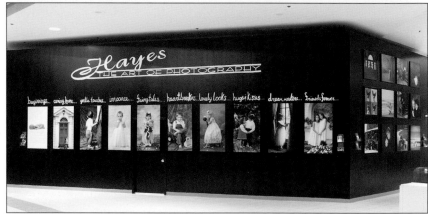

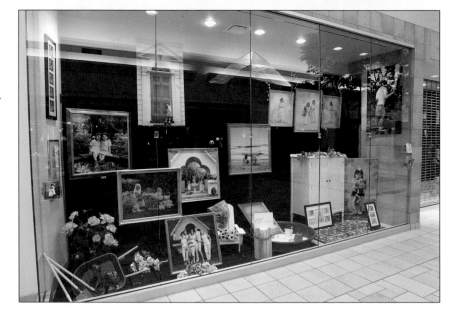

Check your display frequently to be certain it still maintains the integrity you want it to uphold and to see that the cards are replenished. Photograph by Hayes & Fisk—The Art of Photography.

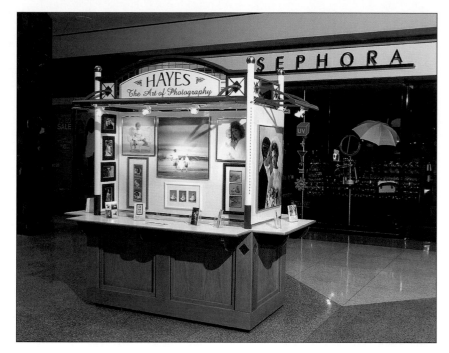

booth appear cluttered. Vicki Popwell, a photographer from Alabama, suggests using the same images in the brochure that are on display to create continuity and enhance the effectiveness.

In summary, once you have set up displays, a website, and a direct mail campaign, be sure to keep them fresh to get the most return for your efforts. Update the look of your marketing promotions frequently and ensure that there is a synergy from item to item and from piece to piece. Once this marketing plan is underway, it is only a matter of time for the phone to start ringing and the sessions to filter in!

4. BOOKING A SESSION

*T*here are three key elements to successfully booking a portrait session with your client: the selection and use of studio management software, good phone skills, and the securing of either a deposit or a retainer.

■ STUDIO MANAGEMENT SOFTWARE

Utilizing effective studio management software will not only make your studio run more efficiently, but it will simplify your marketing endeavors as well. If you can collect information on your customers, you can begin to predict their actions, wants, and needs. When you can accurately narrow your marketing focus to reach only your desired client demographic, you can shave your marketing budget—and a smaller expenditure means a better profit!

Jeff Hawkins, of Jeff Hawkins Photography, explains, "Photo One studio management software (www.granitebear.com) allowed us to pull our studio's operations together. I selected this software so I could easily search through data and better market to current customers and prospective clients. Using this impressive software, I can easily network and track results by customer, promotion, relationship, interests, appointments, and lead source.

"The software comes in handy for scheduling appointments (some varieties may require the entry of data [e.g., a lead source or e-mail address] into certain key fields in order to schedule an appointment). It also helps your staff sound smarter, secures your tracking systems, and helps you to achieve the results you're after." By using this software to track calls and lead sources, and even to document no-shows and cancellations, your company will grow stronger and operate more efficiently.

Jamie Hayes and Mary Fisk-Taylor use SuccessWare studio management software. When scheduling a consultation, Mary uses a form that the software generates to gather as much information as possible about the session. Jamie also uses this form (which is then attached to the client's work folder) to make any notes about the session and sub-

> When you can accurately narrow your marketing focus . . . you can shave your marketing budget.

jects. This is all part of a sales plan Mary created to keep everyone on track for achieving their studio's goals.

There are many studio management software programs offered to the industry. It is important to find a program that offers training and support, continuous upgrades, and networking capabilities. For more on marketing (and workflow) software, see chapter 10.

■ PHONE SKILLS

Next, be sure to sharpen your phone skills—and those of your employees—for the ultimate advantage over your competition! The telephone is the most powerful part of a studio and can often be the studio's weakest link. Who answers your phone, how they answer it, and what they say can optimize your dollars or deplete your bank account!

In conducting research for this book, one of my business associates contacted several studios in order to get her first impression on their products, procedures, and customer service. The results were shocking. Several studios did not respond to the web e-mail information request at all. Most of the places that were contacted had an answering machine greet the client, and the staff took over forty-eight hours to get back to the caller. Some did not even return the inquiry call for over a week! However, interestingly enough, most of the nation's top photography studios had something in common (big or small, residential or commercial): they all had a receptionist greet the caller and schedule a session in a prompt, personable manner. This is the first step to making your advertising dollars work. Follow the guidelines below to sharpen your phone skills:

> The telephone is the most powerful part of a studio and can often be the studio's weakest link.

- **Determine up front who is answering the phone and who is responsible for handling information requests.** Make sure that person understands the importance of responding to all inquiries—whether made via phone or e-mail—within twenty-four hours! Time is money. The longer you wait, the

STUDIO MANAGEMENT SOFTWARE

The ability to track lead sources and schedule appointments is only one benefit of a studio management software such as Photo One by Granite Bear. More information on the benefit of using studio management software is provided in chapter 9.

colder the lead becomes and the greater the likelihood that your prospective client has selected another photographer. Remember, the initial inquiry is your first opportunity to build a relationship and show your customers they are important to you.

- **Create a positive interaction and give the caller your undivided attention.** Answer the phone in a clear, professional manner and state your name. Sound excited and enthusiastic about their portrait session and keep in mind that if you are multitasking while you are on the phone, you are not giving the caller your all—and it will show!

- **Work to develop a rapport with the caller.** Most people who call your studio will ask about product and session prices because they don't know what else to ask. If you are simply in question-answering mode, then you are not bonding with the caller and are probably missing the boat with many of your leads. Interested callers typically ask questions, but turn it around and ask them questions instead. Ask about their family and their wants and needs, and use your studio management software as a guide to ensure that you gather all of the information you'll need. Doing so will help you develop a relationship with your prospective client and will help you gain control. You will sound more intelligent, the caller will feel more comfortable, and you will have a better opportunity to bond with the potential client.

> If you are simply in question-answering mode, then you are not bonding with the caller.

- **Ask for the appointment.** Again, most callers ask about pricing because they don't know what else to ask. Get the information that you need to develop a rapport, determine what type of session the caller wants, and understand their needs. Once that is done, ask for the appointment. There are two basic ways to do so:

"Is there any reason why we couldn't go ahead and put your session on the calendar today, so you are able to take advantage of the holiday promotion?"

"May I make a suggestion? Based on the type of session you are searching for and the location desired, why don't we schedule a visit to the studio so you can view our gallery and review all of your options prior to the session?"

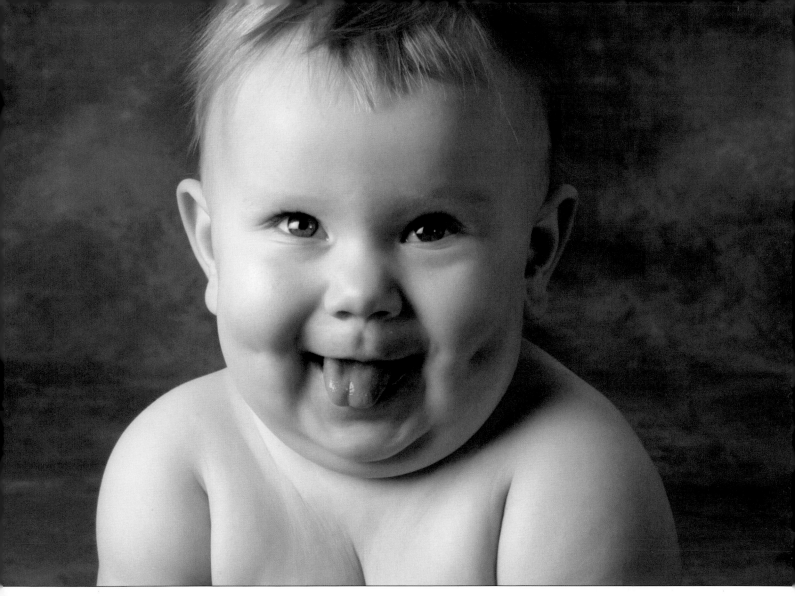

Remember to smile when you are talking on the phone. It will show in your voice! If you need to, place an image on your desk that will keep a smile on your face! Photo by Kay Eskridge.

- **Give only the lowest session pricing level over the phone.** Don't go into excessive detail; instead, discuss the details in person. Quoting detailed pricing over the phone only leads to misunderstandings, arms your competition with information on your pricing, and places the focus on the price, not the artwork. Put the focus on your product.
- **Be sure to get key contact information for each inquiry call.** Consider using a phone interview questionnaire to help track your phone calls and results.

Definite Don'ts

- **Don't place a client on hold.** Avoid this as much as possible. Everyone wants to feel as though they are special and important. Placing them on hold sends a message that something or someone else is a higher priority.

- **Don't forget to e-mail a confirmation.** Send some basic information about the studio, and directions to your studio.
- **Don't chew gum, smoke, or eat while talking to a prospective client.**
- **Don't ask the caller what time they'd prefer to come for the session.** Instead, let them choose from two options. Often photographers will say, "When would you like to stop by?" or "Anytime after 1:00 p.m. would be fine." If you were to call a doctor's office or a law firm, would they give you a choice? Being too open lowers the caller's perceived value of your product and service. Instead, memorize the following questions and use this procedure each time.

"What is better for you, the beginning of the week or the end of the week?"
Answer: Beginning

"Great. Morning, afternoon, or evening?"
Answer: Morning

"Ok, we can do Monday at 10:00 am or Tuesday at 9:00 am. Which would you prefer?"

Again, with this method of appointment scheduling, you are maintaining control, and the prospective client has no clear indication of how busy your schedule is—or isn't.

■ DEPOSITS / RETAINERS

Make certain that your studio has established policies and procedures for collecting deposits/retainers and has set up cancellation and refund policies. This will make matters easier once the client's session is booked. Every studio has different practices, and there is no standard

> Being too open lowers the caller's perceived value of your product and service.

BACKING UP YOUR CLAIMS

The term "digital" in a studio's name won't necessarily assure clients that they'll receive high-quality images. Whether on your website, business cards, or the side of your company van, make sure to back up the "digital" claim with quality work. Remember: it's the product, not the method of capture, that matters.

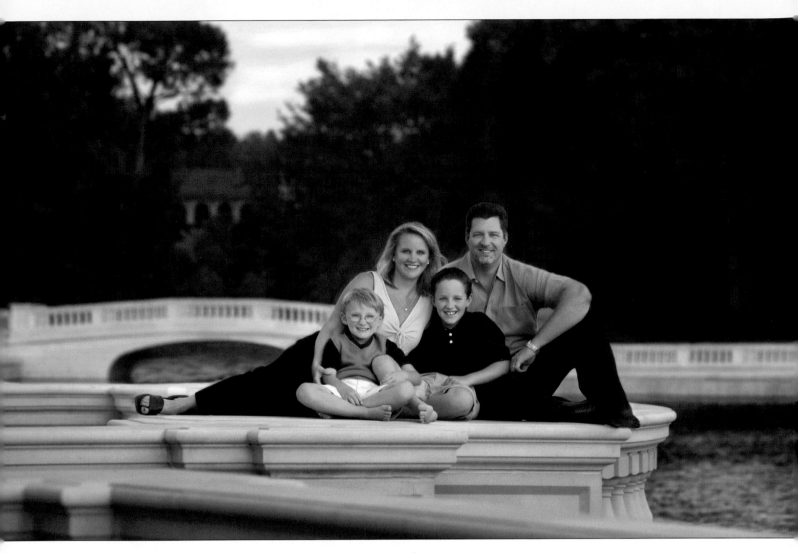

Gregory Daniel believes in collecting a nonrefundable order amount in lieu of a retainer or a deposit toward the session. Image by Gregory Daniel.

guideline to follow. The criteria will vary based on your marketing demographics.

Gregory Daniel of Gregory Daniel Photography in Titusville, Florida takes pride in creating one-of-a-kind images for discerning clients, which are typically displayed on a prominent wall in their home. Gregory explains, "Our clients invest much time, energy, thought, planning, and money during the process of creating their personalized Gregory Daniel portrait. These images evoke emotion and quality through thoughtful care in the design, color harmony, storytelling, and fine craftsmanship." Because of the time and energy spent in preparing for a Gregory Daniel Portrait session, a nonrefundable minimum order amount is required. (This amount will be applied to the final order.) Gregory explains, "I have never been a fan of a deposit or creation fee. I view these methods as negatives and feel as though clients do not understand the true value of either."

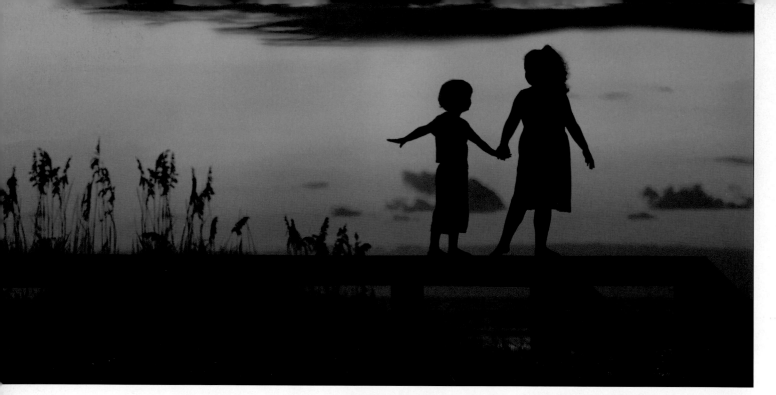

Jamie Hayes and Mary Fisk-Taylor have a different philosophy. Jamie explains, "We require our session fees to be paid at the time of the session. Portraits are paid for at the time of ordering. Our cancellation policy is very simple: if a client needs to cancel their appointment we cancel it whenever they wish. We do not require a certain amount of advance notice. All of our clients are seen by appointment only. If a child is not well and we need to reschedule a session, we do so at the next available time."

Kay Eskridge sees things differently.

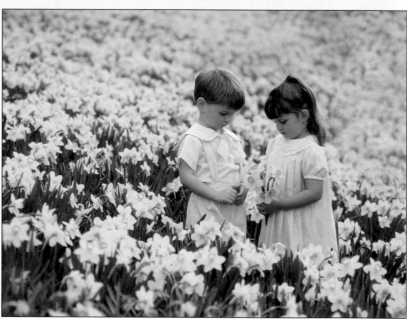

Jamie Hayes and Mary Fisk-Taylor believe in a more flexible scheduling policy and are willing to reschedule when necessary. However, they do work by appointment only. Top image by Jamie Hayes. Bottom image by Mary Fisk-Taylor.

FACING PAGE—It is also common for studios to provide a variety of session options for the client. Image by Kay Eskridge.

Her studio requires an "initial payment" that varies depending on the level of service the client selects (as described below). Kay explains that the term "initial payment" is used because people think that a "deposit" is refundable. If a client needs to reschedule, for whatever reason, the studio rolls the initial payment over to their next session but does not refund it. Kay's pricing philosophy is currently as follows:

- The pricing for a studio session is $300.00 ($150 toward the session, $150 toward the client's portrait order).

Vicki knows several locations along the beach that are wonderful places to photography your family. Portraits are taken just before sunset to provide the perfect lighting for unforgettable beach portraits.

Beach sessions are in high demand and appointment dates are limited, so call and schedule your session with Vicki today.

Vicki Popwell, portrait artist
Andalusia, Alabama

334 222-2727

The Beach

She soothes you with the music of nature

Stimulates your visual senses with her grandeur

and

Invites the opportunity to share her wonders....

- A portrait garden session costs $500.00. ($250 is applied toward the session and $250 is applied to the order.)
- On-location photography in the greater Phoenix area costs $600. ($300 is applied to the session and $300 is applied to the order.)
- The studio's Summer Vacation Experience costs $600. ($400 goes toward the session and $200 is applied to the order.)

Vicki Popwell promotes her beach sessions with a well-designed flyer. Photos by Vicki Popwell.

Kay's studio also offers a "mini session" which costs $100. For this session type, the studio requires that the full amount is paid as the initial payment before the session.

When asked about her cancellation policy, Kay explained, "We have a twenty-four hour cancellation policy but are flexible in case of a sick child, emergency, etc. I am a businesswoman, but I'm a human being first, and sometimes things do happen. I believe being too strict or too uncaring can make for bad feelings for your clients."

Regardless of what you decide to charge for your sessions or what policies you implement for dealing with cancellations, be sure to create a system, set a policy, and *honor* it.

5. THE PRE-SESSION CONSULTATION

*Y*ou can't expect to achieve a portrait worthy of an award if your client is not informed on the best way to ensure a good portrait—*before* he or she arrives for the session. While you might initially consider sending an e-mail containing instructions or a postcard with a list of portrait pointers, your clients need more attention than that. By conducting a face-to-face meeting you can familiarize clients with your studio environment, determine their portrait needs, coach them on their role in achieving great portraits, help them get to know you, and ultimately ensure the best possible results. This is also the time to confirm session details and policies.

■ THE STUDIO ENVIRONMENT

In a portrait studio, image is everything. It's important to ensure that your studio sends the right message to prospective clients. If you are one of the many photographers who run a studio from home, for instance, be sure that your studio area is a distinctive, separate area. For such an arrangement, try designating a mother-in-law apartment as your studio space, using a separate entrance into the space, or creating a distinctive space by creating a large, wide entryway to give clients the impression that they are walking into the gallery. No matter which option works for you, be sure to feature your best images—

Each area of your studio should send the right message to prospective clients. Photos by Hayes and Fisk—The Art of Photography.

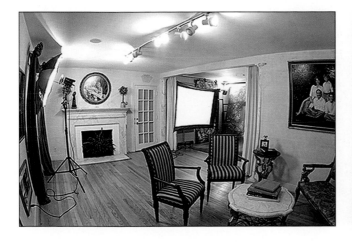 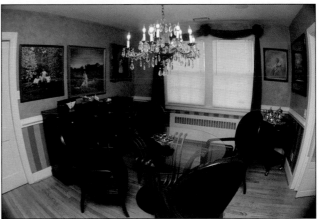

representing each client demographic—in your lobby. (Be sure to update these often to keep the look fresh and up-to-date!)

Some clients feel more comfortable coming to a commercial studio space and for this reason, many photographers rent or own commercial studio space. If you have chosen this option, you'll still need to hang prints and choose furnishing that are well-suited to the clients you wish to attract.

The bottom line is that customers need to feel comfortable in your studio. Here are ten ideas for ensuring that this is the case.

The bottom line is that customers need to feel comfortable in your studio.

1. **Examine the location.** Whether you are running a residential gallery or a commercial space, location is important. Make certain your studio is easy to access. If you elect to use a residential gallery, add the money you save to your advertising budget. This will help make up for a lower visibility.

2. **Don't allow clutter in your studio.** Have a friend or colleague critique your establishment on a quarterly basis. You will be amazed at what you've turned a blind eye to!

3. **Spend money on décor!** Decorate to appeal to the clients you want to attract.

4. **Decorate with items that can double as props in the camera room.** By doing so, you will conserve both space and money. In our studio, for example, we've decorated the lobby with vintage suitcases and an old globe-like storage container.

Consider decorating with items that can double as props in the camera room.

Whether elaborate or simple, it is a nice touch to provide a self-serve refreshment center for your clients.

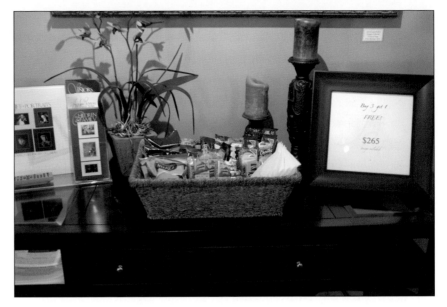

The suitcases provide storage space for our art prints, add a little pizazz to our lobby, and can be moved to the camera room to feature in an image! The globe is sturdy enough for a little kid to sit on, so it too can be effective as a camera-room prop!

5. **Create a self-serve refreshment area.** Many clients will not ask for refreshments—no matter how hungry or thirsty they may be. Others will not accept something to eat or drink, even if you offer! Providing refreshments where your clients can easily access them, should they be so inspired, will make them feel more at home. In our studio, we didn't have the space to add a refrigerator and a kitchenette area, so we compromised by adding a basket full of goodies. Upon arrival, all clients are offered something to drink and, if they decline, they get a small bottle of water just in case!

6. **Decide on the feel you want.** Determine early on whether you want a homey studio or one with a more commercial feel, and decorate accordingly.

7. **Remember, less is often best!** Think of a designer store such as Gucci or Fendi and visualize their product display. Next, think of Kmart or TJ Maxx, and visualize their product displays. Which one has a higher perceived value? Often showing less and presenting the right product at the right time will reap bigger results.

8. **Treat each day like company is coming.** You never know who may walk through your studio doors or when they may enter. Be sure to be your very best version of yourself!

Presenting the right product at the right time will reap bigger results.

TECHNICALLY SPEAKING

While you may be excited about your digital camera and the changes in technology, your enthusiasm may not be reassuring to your clients. In fact, your new style may actually scare your clients away rather than attract them to you—especially if you are not careful with the wording you use.

Be sure to keep the focus on your art, not on your equipment. Market the technology indirectly by introducing new image styles to your clients rather then educating them on the skills or equipment used to create the work. (Before you began this transition, did you feel compelled to educate clients on the Hasselblad or Canon camera you were using? Most likely not; in fact, it may have even annoyed you when a client asked you what type of equipment you used. If that is the case, why should the digital experience be any different?)

Once you begin showing high-quality digital imaging in your advertisements, studio, or on your website, people will begin noticing the difference in your innovative product and style.

9. **Begin each day by preparing your studio for guests.** Turn on music and lights, clean the bathroom, vacuum, brew coffee, and make sure your place smells pleasing.

10. **Invest in property and liability insurance.** Also make sure that your studio is free of safety hazards. Always keep your customers' well-being in mind!

■ THE CLIENT'S ROLE

Up to this point, our discussions have revolved around the image we want to portray to our clients. The next phase involves determining what the client wants—and showing them how to best achieve it.

It is important to ask questions to better understand the type of session the client envisions. At this stage, it is your job to listen to the client—not to sell them on your studio. This should be an emotional exchange, not an information exchange! By asking the right questions, you can begin to create a bond with your client. The following list will put you on the right path.

> Ask questions to better understand the type of session the client envisions.

1. What is your vision?
2. Who will be in the photograph?
3. Have you seen an image style that you particularly relate to?
4. What do you like and dislike about the images you see here in the studio?
5. Tell me about your past portrait experiences.
6. Do the people who will be photographed have any special needs or limitations (e.g., handicaps, ages, pets, etc.)?
7. Where will you hang your image?

Once you learn more about your client, you can discuss what type of session is best for the subject. (In the pages that follow, I'll discuss some of the portrait styles offered at Jeff Hawkins Photography.) A word to the wise: narrow the scope of the portrait session to just one type. Too many photographers try to do everything at a single session, which eliminates the need for the client to come back for another portrait.

To sell your client on your services, use the following pointers.

1. Determine what type of session you want to do at each stage of your client's life.

To prepare for your portrait consultation, be sure to educate your client about the benefits of a clothing consultation, retouching, and professional processing with their portraits. Image by Gregory Daniel.

TALKING ABOUT DIGITAL PHOTOGRAPHY

When it comes to communicating with your clients about new technologies, it's not just what you say that matters, but how you say it. Here are some tips:

1. Don't say: "We are a proofless studio!"

Implying that you are proofless tells clients that they receive less with you than with photographers who give away proofs! You do use proofs, you just don't use paper proofs.

Instead, say: "Here at John Doe Photography, our state-of-the-art digital technology allows us to offer you more convenient proofing methods. All of our clients can view their images in three different ways: on-line ordering for your family and friends, a proofing CD, and a professionally bound contact sheet with each edited image, numbered for reference. You don't ever have to worry about lugging and shipping heavy proof books again! Our clients find this to be a faster, easier, and more convenient way of sharing their images with family and friends."

Now, doesn't the second option sound more appealing than the first? With the second option, it appears as though your clients are receiving more, thus increasing the perceived value of the service you are offering.

2. Don't say: "We are completely digital!"

Instead, say: "Our studio utilizes top-notch, state-of-the-art equipment. As an experienced portrait artist, your photographer will use whatever camera is most appropriate for the subject matter and style being photographed. Don't worry, we have plenty of backup equipment! That is one of the main benefits to hiring an experienced studio."

Again, doesn't the second option sound more appealing? Remember, many of our couples have unfortunately been misinformed by people or publications about digital imaging. They believe that you are using the same digital camera as their Uncle Bob. If you have backup equipment, the recommended statement is 100 percent accurate. Depending on the circumstances and how far out the session is scheduled, you really can't promise today what equipment you will be using tomorrow. If your equipment was stolen, or some other crisis occurred and you had to rent or borrow equipment, you don't want to be legally liable to have to capture the event with a specific type or style of equipment. Even though you may be completely digital 99 percent of the time, by selecting your wording carefully you have just overcome the objections of camera selection and backup equipment. The key is you overcame their objection before they even asked the question! You have also protected yourself in the event of a camera change.

3. Don't say: "Oh, I can have that done in a minute, I'll just print it out on my printer!"

Instead, say: "Let me see what our production schedule looks like and how quickly we can get that into processing. I will do my best to get your order processed as quickly as possible for you."

Clients still find comfort in knowing their images went through a magical chemical process. They are often more skeptical of digital output process than the digital capture. The faster it appears that you can turn the print around, the more you depreciate the value of your image. If a client does need to expedite the process, then make it appear as though you have made an exception in the workflow, and never get it done too quickly! It may only take a few minutes to create a driver's license photo, but it takes more than a few minutes to create a work of art!

Also, be careful never to reveal too much information on the type of printers you use. As quality of printers increase and the cost decreases, more and more clients are familiar with (and own) these high-quality items. However, if a client asks directly, what kind of printer do you use? then tell them.

Make sure you also overcome the archival question, even if the client doesn't ask. You would never want your client to think they could create the same image as you! Your entire process from image capture to presentation should be a magical work of art, a special talent that only you know!

Maternity sessions can be conducted in a private outdoor location. Discuss with your client their comfort level and desires. Image by Mary Fisk Taylor.

Listen to your client and guide them in the direction that best suits their needs.

2. Identify the type of products you hope to sell after the session.
3. Coach the client on what they are about to experience and how they can best prepare.
4. Develop a strategy for marketing your unique products and build the client's desire to experience that type of session and purchase those one-of-a-kind portraits.
5. Use the Good, Better, Best philosophy to describe your portrait sessions and product packages. (Too many decisions lead to fatigue, frustration, and confusion.) Listen to your clients' needs and desires and guide them in the direction that best suits their needs.

Different sessions require varying approaches. Some of the basics follow.

■ MATERNITY SESSIONS

A maternity session is typically photographed in the studio but can be done in a private outdoor session as well. Conduct the session at the six- to eight-month mark. The bigger the belly the better, but don't

schedule the session too close to the due date or you may miss the opportunity!

Encourage Dad to come with Mom—and maybe even a brother or sister. These family members make great "props" in the portrait! Be sure to discuss any other appropriate props for the image, as well as background choices, prior to the session.

Instruct the mom-to-be to bring a cute button-down maternity top (preferably in white, brown, or black). These colors can help to establish a classic look in the image. Lacy bra tops or long, see-through robes also make for attractive portraits (and showcase the rounded physique!). Remember,

Encourage Dad to come with Mom to the maternity session. Image by Kathleen Hawkins.

your wardrobe for the pregnancy portrait should be as classy as the client. Often, wrapping the subject in a fabric wrap that isn't very attractive may limit your sales. You may want to have a large white button-down men's dress shirt or a white silk robe on hand as a back-up, in case the mom-to-be comes unprepared.

Many parents choose to purchase a guest book or a framed print to be displayed at the baby shower. Others display a maternity image in the baby's room. Options and opportunities are endless, but you should have a well-defined plan for the session before the client arrives for her portrait.

■ **BABY-PORTRAIT SESSIONS**
Homecoming Images. This session type covers the birth, first days, and homecoming of the baby. This type of session is usually conducted on location. These are all important moments your clients may

THE DELIVERY ROOM

If you plan to cover a delivery, be sure to consult with the client's physician prior to the delivery date to determine the rules and regulations for professional photography in the hospital or during the delivery.

want a professional to cover, because like a wedding event, they will never have a second chance to document these special moments. Sometimes, people try to rely on a family member to capture these images. However, it is usually a very hectic and emotional time for everyone involved, and it is easy for family and friends to get caught up in the excitement of the moment and miss a powerful image opportunity.

Homecoming sessions are best displayed in the form of an album. Many album options are available—from coffee-table books to traditional albums. Discuss these options with your client before the session(s).

0–3 Months. Unless the session can be conducted while the baby is still in the hospital, these sessions should be held at the client's home or in the studio, as an indoor session is more calming and less disruptive for the child.

Don't create an image with lots of frills. Too much fabric can be constricting and can conceal the baby's tiny limbs, hands, and feet. An artful image of a nude baby can really accentuate their newness and

Creating an intimate close-up of the mother and baby is a fantastic way to document the bond between a mom and her newborn. Photo by Sherri Ebert.

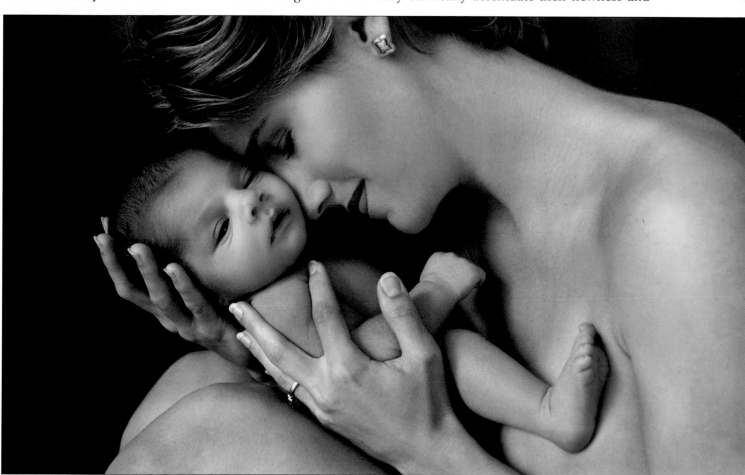

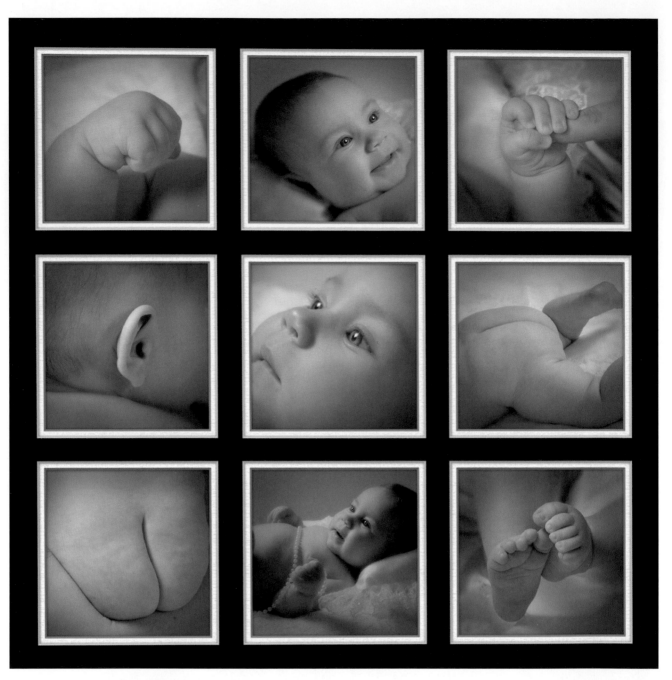

smallness! However, if a nude baby image isn't what the client prefers, it is best that the child be dressed in simple clothing that complements the child's skin tone. Intimate close-ups of the parents with their babies are another client favorite. For these images, have the parents dress in solid, dark clothing that ensures that viewer's focus will be drawn to the child. Because babies typically feel comfortable in Mom or Dad's arms, these portraits tend to be a favorite.

These images are great for greeting cards, framed images, and are a great starting point in "baby's first year" albums.

Frank Donnino coined his "baby parts" frame the Kissable Collection. It's a cute way to capture all the tiny features parents love so much. Photograph by Frank Donnino.

3–6 Months. These sessions are best conducted in the studio or in the client's home. Baby can sit up at this point, so posing in a rocker, on a bench, in a swing, or on an Adirondack chair works best. Select a wardrobe that will help to show the child's personality. Encourage your client to add a bonnet for a baby girl or a hat for a little boy—and sunglasses are always a cute addition. Denim overalls and frilly dresses make for great clothing choices.

Wall folios or multiple-image frames are the most popular choices at this stage of the baby's life. The multiple images give you an opportunity to bring out the child's expressions and to showcase various facets of his or her personality.

6–9 Months. During this age, the baby seems to be changing daily and is growing ever accustomed to the world around him. For this age range, sessions can be held indoors or out. At this age, baby can stand while holding onto a prop (chairs, fences, and other sturdy props make good choices here).

At this young age, there is not a lot of movement, so to help capture the child's personality, use wardrobe and props. Image by Frank Donnino.

At this age, the clothing options are endless, but remind your client that solid, neutral colors work best in the portrait. It keeps the focus on the subject.

These images are a great addition to the baby's first year album and make great framed images too. Sessions can be held indoors or on location at this point.

12 Months. Baby is walking on his/her own at this point. Sessions should definitely be held on location. This is their "I am *free!*" session, so pick a great location like the first birthday party or a local park (perhaps one with ducks!).

Clothing options are endless for this age range too, though solid, neutral clothing works best. (Check out www.strasburgchildren.net for some great, timeless clothing options.) Kids love to play dress-up at this age, so consider including a piece of mom or dad's work or casual clothing—or a special prop—in the image.

Large, custom-framed images are popular with parents of subjects in this age group. The images also finish off the baby's first year album.

The first year of baby's life is one of the most difficult to document, because the child's personality and looks change so fast. Be sure to encourage clients to have the child professionally photographed at least once a year (these make great holiday portraits) and to bridge the gaps with lots of captures at home!

■ **HOLIDAY SESSIONS**

The holidays have traditionally been a good excuse for people to capture images of the ones they love. These photos are wonderful for inclusion in e-mails and holi-

During the twelve-month session, the young client is free to wander and ready to explore. Photo by Jeff Hawkins.

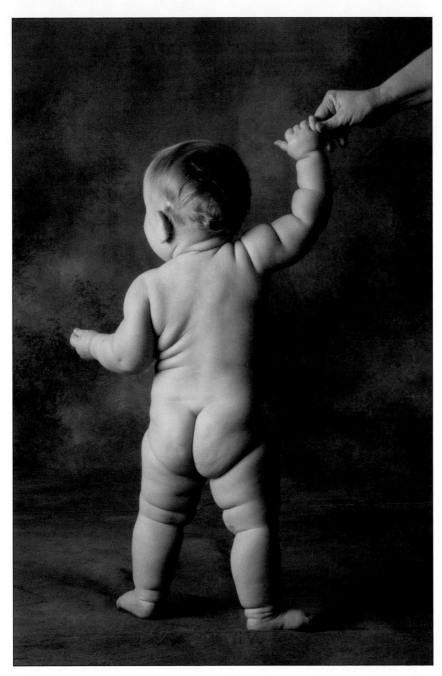

At this stage, clothing is optional! Photograph by Kay Eskridge.

day cards and make great gifts for friends and families. Do not wait until October, November, or December to market these sessions. Many successful studios offer "Christmas in July" portrait specials! The holidays are the studio's busiest time of the year; marketing early will help you to avoid headaches!

Also, encourage your clients to think beyond their immediate family and include extended family members in the portrait. An image of grandma with the grandchildren is always a treasured classic. When scheduling these images, remember to consult with the portrait subjects on their wardrobe and their vision of how the portrait should look. Ensure that each family is dressed in clothes that coordinate. As always, solid, neutral colors photograph best.

■ SPECIAL-EVENT SESSIONS

There are a number of times when special milestones or events will warrant the taking of a special portrait. These can vary from client to client.

Religious/Cultural Events (Baptism, First Communion, Mis Quince Anos, Bat/Bar Mitzvah, etc.). These religious/cultural events can consist of standard, in-studio portrait coverage or elaborate event coverage on location. The extent of the coverage can vary and should be discussed with your client. Prices will vary based on the type of coverage, the number of people being photographed, the time requested, and the desired product.

Wardrobe will vary depending on the religion and type of portrait desired.

Many families choose images from these events to showcase in deluxe albums, in custom frames, as announcements, and gifts.

Kindergarten Graduation Session. Don't underestimate the importance of capturing kindergarten graduation photos. Capturing this image reinforces the importance of the occasion and marks the completion of the first step toward the client's educational goals! This session can be photographed using the child's graduation outfit or a miniature traditional graduation cap and gown. These photos make great gifts or can be used for graduation announcement cards.

Sweet 16. If your client doesn't have their child photographed for a cultural/religious ceremony at about this age, then they should consider a Sweet 16 photo session (if for no other reason, then for your client to remind their grown child how much trouble they were when they were a teen).

Get funky with the wardrobe for this photo. Ask questions to gain insight into the teen's personality and try to make each session unique.

At this age, the child will want pictures to share with their friends. The parent will want a framed print to display at home.

Senior Portraits/High-School Graduation. Sure, schools will provide some sort of graduation image for an announcement and yearbook photo. Nevertheless, nothing will document the new graduate's personality and this important moment in their life better than a Day in the Life session with a professional photographer.

A Day in a Life session is one in which a photographer chronicles the events—and the details of those events—through one given day. These storytelling images can showcase many of the things that helped to shape the teen's high-school identity. For instance, you can photograph the client with an instrument, a letter jacket, their new car, etc. Keep in mind that while this is initially an important photo for the parent, it is one that will become an heirloom for the teen as well.

Clothing can consist of a cap and gown, uniforms, or anything else that illustrates the subject's personality.

These photos make great custom-framed portraits, can be used to give away to friends and family, and can also be used for graduation announcements.

By this point, you should have a clear understanding of your client's basic portrait needs and should be able to communicate to the client the importance of hiring a professional to assist them in capturing the highlights of their children's growth. With a little creative marketing

WORKING WITH KIDS

Jamie Hayes of Hayes & Fisk— The Art of Photography states, "It is not easy to get children dressed and 'posed' while they are still in a good mood and while you have not lost your patience. Professional photographers create wonderful images because they are not authoritative figures for their little subjects and can keep their curiosities satisfied for the length of the session."

At this age, the child will want pictures to share with their friends.

Nothing will document the new graduate's personality and this important moment in their life better than a Day in the Life session Photo by Jeff Hawkins.

and and client education, your portrait relationships will continue to flourish.

The above guidelines ideas are just a few of the session types you can offer to your clients. You will find an option and a style that works for you. Just be certain to encourage different looks, styles, or locations *for future sessions*. If you deliver every option the client might like at once, why would they come back?

Also, when scheduling your session, be sure to make a notation in your studio management software as to whether the session will be held indoors or out. (Doing so will help the photographer better prepare for the shoot.) Also, while parents might push for a session that incorporates both indoor and outdoor images, this is not recommended (unless it is for a senior portrait session). For younger children, using more than one outfit or location will usually become too overwhelming.

■ PORTRAIT CONTRACTS

After you discuss and review basic portrait session requirements, complete a portrait contract (see pages 115–18 for a sample contract) if required and discuss proofing procedures and ordering policies. By this point, your client should have a clear understanding of your studio's philosophy, their session goals and location, and the products they desire. They should also be familiar with the ordering process and the turnaround time for their images. Then, all they'll have to do is get ready for the session!

Many studios don't utilize portrait contracts. However, a contract can protect you from lawsuits and may help provide leverage for han-

dling past-due accounts—and much more. While some photographers may feel that their studio's operations are too streamlined to require a contract, it's typically better to be safe than sorry. Problems can creep up at any time—especially when the client–photographer relationship is long-lasting (say, in contracting with a client to complete the baby's first-year photography or for members of your Lifetime Portrait club).

When drafting a contract, here are a few pointers to keep in mind.

Make sure your client understands when payments are due and what the policy is if they cancel or want a refund. Photo by Jamie Hayes.

- **Be sure the contract specifies the name of the studio and the photographer.** It is important to state who will be capturing the event.
- **If you are contracting to capture the homecoming of an adopted child or a birth, be sure to include an availability clause.** Since the date and time of the event can't often be nailed down, you may later run into scheduling problems.
- **Make certain that all fees are carefully itemized.** Clearly noting each fee will help eliminate confusion.
- **Make sure your client understands when payments are due and what the policy is if they cancel or want a refund.** There are times when you may run into clients who are reluctant to live up to their portrait plans. For instance, if a baby is born with complications and the parents no longer wish to photograph the first several sessions and want a refund, you'll need to have some clear-cut policies in place.
- **Make sure the contract covers proofing policies.** How many proofs will your clients receive? How will you review them?

While editorial usage of an image does not require a model release, just about any other use does.

How will the proofs be showcased? If the images are going online, will they be password protected for privacy?

- **Be sure that file/image ownership rights are clearly defined.** Copyright law can be difficult to decipher and can be easily misunderstood. Be sure to make it clear that your client is paying for a service and that once their image has been created, you own the rights to that image. Thus, copying or reproduction in any form, of any photograph, is prohibited and protected under Federal Copyright Laws and enforced to the fullest extent of the law. With client access to scanners and picture-making machines found in retail establishments becoming increasingly prevalent, clients need to know that infringing these laws can be extremely costly—and is definitely *not* worth the benefit or possible savings. In the contract, be sure to indicate how long you will keep possession of the negatives or digital image files and how much you will charge for copyright release of the images.
- **Copyright laws protect photographers, but the subjects in your images have rights, too.** Before a photographer can publicly display the images (e.g., in the studio lobby, in print ads, in mall displays, on their website, etc.) they must have a model release, signed by the client, that specifies the ways in which the images created during the session can be used. While editorial usage of an image (i.e., use in a newspaper or book, so long as the material is used in good taste) does not require a model release, just about any other use does.

Once you have reviewed the required documentation and covered each of the above considerations, it is most likely safe to have your client sign on the dotted line. Be sure to make a copy of your paperwork for your files as well as for your customer.

MODEL RELEASE FORMS

Discuss the model release form with your client. If you plan to use your client's maternity image on your website or in your digital portfolio, for instance, you'll need to be sure that she's comfortable with its display before she signs the release! Also, if you provide online proofing, be sure to let the client know whether or not the images will be password protected.

6. THE DIGITAL DIFFERENCE

The majority of professional digital equipment today is more than adequate for portrait sessions, but the image output quality will vary based on the user's knowledge and skill level. Overall, selecting equipment is a personal preference and typically will be determined by the type of professional equipment the photographer currently owns. (More detailed information on the digital technology available and equipment considerations can be found in my book, *Digital Photography for Children's and Family Portraiture* [Amherst Media 2004].)

Let's now explore what some award-winning photographers are using and get their thoughts on this new technology. (For a refresher on how to handle the topic of shooting digitally with your clients, revisit "Talking About Digital Technology" on page 58.)

■ GREG AND LESA DANIEL

"Digital has helped us take a huge step closer to producing a product that captures what I saw in my mind when the image was created," says Greg. "The advancements in retouching techniques have dramatically changed with the onset of digital capture. In the past, most of the manipulation or image enhancement was produced by outside suppliers to our business. Today, most of the enhancements are made in-house and can be achieved closer to our standards."

"Digital photography is just another tool in the toolbox for our profession," says Greg. "There will always be a need to provide artistic imagery for discerning clients. I believe there is a real desire for image-makers that can create a mood, artistically design a scene, evoke an emotion, and craft the final product."

While Greg considers shooting digital to be an advantage overall, he says, "The learning curve, startup cost, and time commitment is astronomical."

Gregory Daniel uses the full Canon digital system. He shoots with a Canon 1Ds and uses a host of Canon lenses. The favored portrait lens is the 70–200 2.8 L-Series lens. Indoors, Greg prefers natural win-

> "Digital photography is just another tool in the toolbox for our profession," says Greg Daniel.

The advancements in retouching techniques have dramatically changed with the onset of digital capture. Photo by Gregory Daniel.

dow lighting. However, he uses the Photogenic system when needed. Outdoors, he is partial to using a Quantum Q flash.

■ FRANK DONNINO

"The biggest advantage of digital technology is the ease of finding images and reordering samples. Plus with the cost-effective benefits to

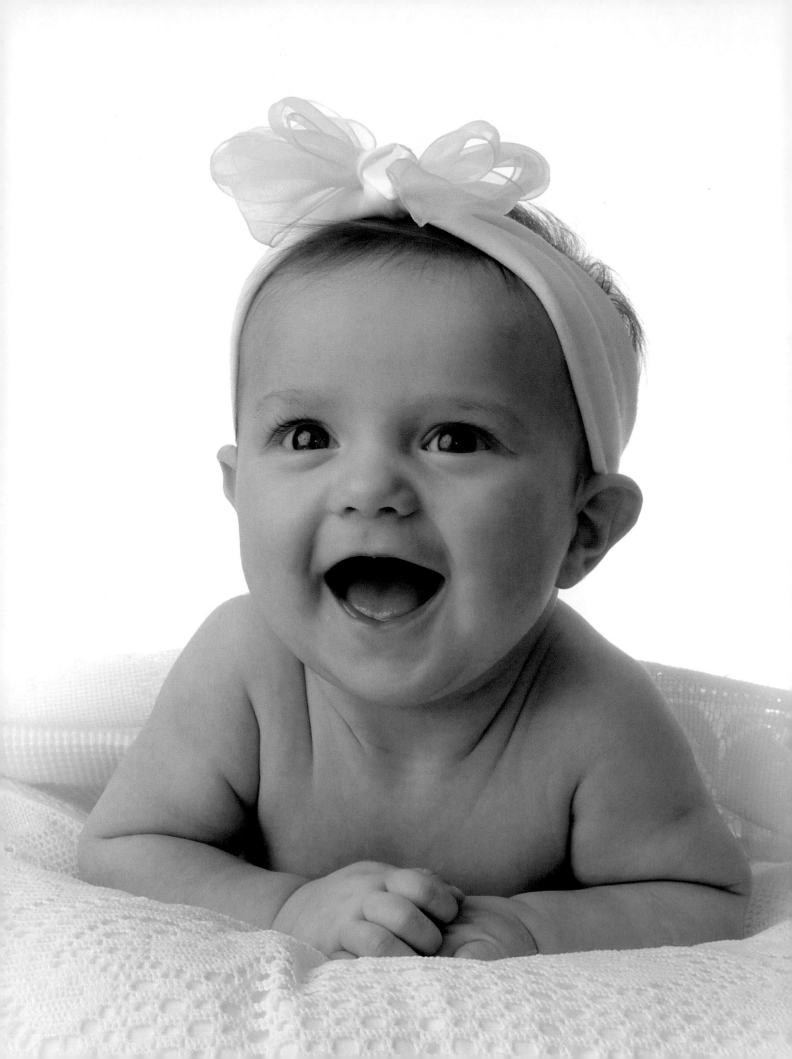

digital capture, having the ability to barter out mall displays in exchange for images is a huge bonus!" says Frank.

Frank is aware of a downside to working digitally. He says, "Photoshop becomes the second shift of photography. Therefore, the biggest disadvantage is the time-management issue involved with digital capture." Frank suggests that photographers use as many actions as possible to expedite the file preparation and retouching process.

In the studio, Frank uses a Fuji S2 with a Nikon 80–200mm lens or a 28–70mm lens. His in-studio lighting equipment consists of four Photogenic 1250 DRs: one as a fill light, one as a main light, and two to light the background. On location, Frank uses a Canon 1DS with a Canon 70–200mm lens and a Quantum Q flash TTL S2 as a portable, supplemental flash.

■ KAY ESKRIDGE

Photographer Kay Eskridge says, "We've found the benefit of using a digital camera is its portability and ease of use. It gives us more creative ability. This is especially important when photographing fast-moving children."

FACING PAGE—Photo by Frank Donnino.
BELOW—Photo by Kay Eskridge.

Owning a digital camera and knowing something about Photoshop does not make someone a trained professional photographer.

Kay believes, "The time it takes for a professional photographer to learn the techniques and skills required to make a photograph a portrait instead of an amateurish snapshot can be a disadvantage of digital capture. Also, the need to reeducate the consumer on the difference between an amateur portrait and one taken by a professional can be a disadvantage. Owning a digital camera and knowing something about Photoshop does not make someone a trained professional photographer. It's the professional's knowledge, techniques, and skills that make a photograph a portrait instead of an amateur snapshot. As professional photographers, it is up to us to educate our clientele about the difference between what we are able to do for them versus what they can do for themselves. To help our clients see this, we use terms like 'electronic capture' instead of 'digital photography' when referring to the type of image capture we will be providing. This way, they don't equate what they can do with their digital camera purchased at Best Buy with what we can do with our professional cameras. Today's digital technology is simply just a tool we can use when creating images for our clients—it's still our responsibility to be professional and produce good, high-quality, solid imagery."

Kay uses three digital cameras to capture her charming images—a Fuji S2, Nikon D70, and Nikon D100. She favors Nikon Nikkor lenses and uses five types: the 70–200mm 2.8, 35–70mm 2.8, 28–70mm 2.8, 18–70mm 3.5, and 20mm 2.8. She also relies on a SB80 Speedlight (on-camera flash), PocketWizard Plus, a Stroboframe bracket to hold the camera onto a Bogen tripod, Tamarac bags, Minolta light meter, and a Chameleon reflector. For in-studio lighting, the studio uses Norman LH500 lights, Photogenic Powerlights, and Photoflex light domes (in a variety of sizes).

■ SHERRI EBERT

Sherri Ebert has been working 100 percent digitally for over three years. "As with anything," she says, "there are pros and cons. However, for me, the advantages far, far outweigh the disadvantages." Sherri has provided a list of digital advantages. These include:

- **Being able to shoot more images and therefore getting more great shots for my clients!** I hate being limited by rolls of film!
- **Digital comes in handy when photographing moving subjects like children!** (I cannot believe I ever photographed

children on film!) When you are chasing around two-year-olds that only pause for a millisecond, it is extremely stressful waiting for your proofs to come back and praying that you got something! It's still hard to chase around two-year-olds, but at least you know whether you got it or not! And, all you have to do is delete the bad ones, not line your wastebaskets with expensive prints.

- **Being able to experiment with things you may not have wanted to waste film on before.** I am able to look at things from a more creative perspective. I try wacky, crazy stuff just to see what I can get. When you do, you sometimes end up with beautiful "happy accidents" or discover new ways to look at things.

- **Not needing to juggle multiple cameras to shoot a variety of image types (color, black & white, sepia, and infrared).** Not having to stop to reload film as often pretty much put my assistant out of a job!

- **With digital, you can see the image instantly.** You can correct exposure settings, white balance, etc., as opposed to having to wait a week to get proofs back, only to realize that you goofed or your camera was broken.

- **The ability to retouch my own images, convert to black & white or color, and to add special effects and photographic edges.** This has had the biggest impact on my business. The retouching that I do was not feasible by any means with film: not only was it extremely expensive, but it was never to the quality that I

Digital imaging prevents you from lining your wastebaskets with expensive prints— you keep and print only the good ones. Photo by Sherri Ebert.

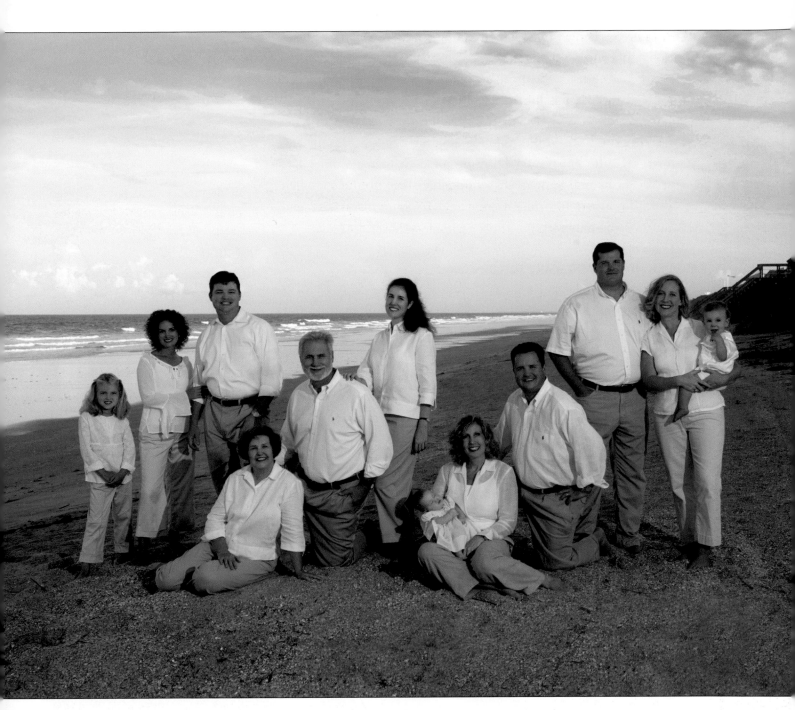

With digital, you can correct exposure settings, white balance, etc., as opposed to having to wait a week to get proofs back, only to realize that you goofed. Photo by Sherri Ebert.

expected. With digital, just one image has to be retouched, and you can print the number of copies you need, as opposed to hand-retouching every individual image. For this reason alone, I cannot see ever shooting film again!

Sherri feels that one disadvantage of shooting digitally is that you can spend too much time on your images post-capture. Because you are no longer limited to the number of images on a roll of film and can eas-

ily retouch your images in an image-editing program, the time it takes a photographer to prepare images for the client is longer than ever. "However, " she says, "the artistic benefits that stem from these possibilities far outweigh any disadvantage!

Sherri uses the Canon 1D and 1Ds Mark II camera system. Her lenses of choice are a 28–70mm 2.8, 70–200mm 2.8, 28–135mm 5.6, 50mm 1.4, 15mm 2.8, Canon 420, 50mm Macro, Sigma 8mm 1.4

Sherri uses natural light whenever possible—and bounces it when she can. She also relies on a Canon 550 EX on-camera flash and Quantum Turbo batteries.

■ JAMIE HAYES AND MARY TAYLOR-FISK

www.hayesandfisk.com

Jamie Hayes and Mary Fisk-Taylor feel that shooting digitally is free from disadvantages. Jamie says, "Using digital capture allows us the ability to have a clients' finished work delivered in just about any timeframe needed. We still have our clients schedule an appointment

Using digital capture allows you to have a clients' finished work delivered in just about any timeframe needed. Photo by Jamie Hayes.

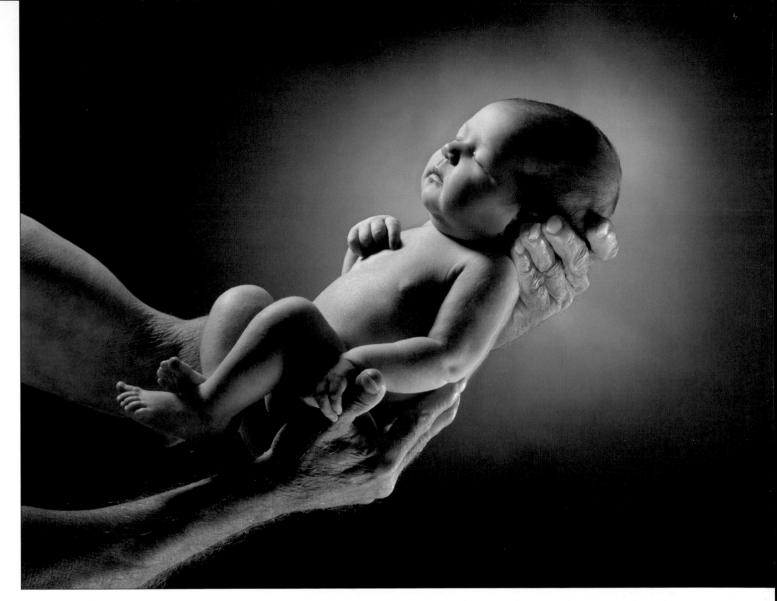

Having the ability to expedite the portrait process as needed is a huge bonus of digital imaging. Photo by Mary Fisk-Taylor.

to order after the session is complete, but having the ability to expedite the process as needed is a huge bonus!"

For Jamie and Mary, the camera of choice is the Kodak DCS 560 for most indoor portraits. They prefer a Mamiya 645AFD equipped with the Kodak 645M Pro Back for all location and environmental work.

■ JEFF HAWKINS

www.jeffhawkins.com

"Digital technology allows photographers to be more creative and inspired," says Jeff. You now have more control over the artwork produced, thus giving you the ability to charge more for *artistry*, not just a photograph. Also, the use of technology can make the capture and post-production processes more exciting and rewarding."

"Some would say that shooting digitally costs more (in equipment), though I think the savings in proofing and production bal-

Digital imaging does require spending more time in front of the computer. Photo by Jeff Hawkins.

ances out the cost. It does, however, require spending more time in front of the computer. Though this is true, remember that the time you spend is making you a better artist. As artists, we must evolve. If we don't, we fall behind the pack. There is a new talent emerging, and these talented photographers have grown up with digital technology. Growing with the industry is vital to continued success."

Jeff is currently using the Canon 1Ds and the 20D. This system also includes the following lenses: 70–200 2.8, 28–70 2.8, 16–35 2.8, and the 200 fixed 1.8.

The environmental portrait lighting is handled by the Canon 580 on-camera flash and the Quantum system. Jeff uses Quantum's new

T4d flash head with the 2x2 turbo battery pack and their freewire transceivers.

In the studio, Jeff uses four Photogenic 1250DR power lights—one as a main light, one as a fill light, and two on the background. He also uses the Larson line, including one 4x6 SoffBox RS, two 14x48 Soff Strip RS, and one 10x36 Side Kick for a hair light. For white balance and exposure control, Jeff relies on an Ed Pierce Photovision TARGET.

For white balance and exposure control, Jeff relies on an Ed Pierce Photovision TARGET. Photo by Jeff Hawkins.

■ CHARLES AND JENNIFER MARING

Charles Maring is excited about the advantages that digital technology provides. He says, "We use digital technology exclusively. The advantages are tremendous. I could write a book on the benefits to the client, but I'll sum it up like this: Due to instant preview, digital capture gives the photographer the ability to know that they completed an assignment to the utmost degree. Digital tools give the photographer endless capabilities to create one-of-a-kind, original art with consistency. Therefore, there are no excuses, and the client should expect a superior and consistent image quality." He feels that only the fact that it takes more valuable time to create digitally is a detriment in working with digital. He says, "Due to the quality increase and creative time involved, the client should expect to pay a higher price for digitally-mastered photographs."

Digital tools give the photographer endless capabilities to create one-of-a-kind, original art with consistency. Photo by Maring Lifestyle Photography.

The Marings shoot with a Nikon D1x but recently added a Canon 1Ds Mark II and Canon lenses to their camera bags. Their favorite portrait lens is the 70–200 2.8. They use Bowens Prolights indoors with a small softbox as the main light and a silver reflector as a fill light. A striplight softbox is used as a hair light. For outdoor portraiture, the Marings use Quantum X and Quantum T packs when they are outside or on location doing environmental portraiture.

7. CONDUCTING THE SESSION

*a*fter all of the preparation and waiting, the time is finally near. It is time to capture the image and create a family heirloom. Review your studio notes from the consultation and determine whether you'll be shooting indoors or out. It is recommended that you conduct only one style or the other. Though both can be accomplished, many parents may expect it in the future. Remember, each time you combine a session, you prevent another from occurring.

Each time you combine a session, you prevent another from occurring.

■ NARRATIVE ENVIRONMENTAL SESSIONS

We refer to our outdoor portrait sessions as narrative environmental sessions. Typically, the photographer will use a longer lens and direct the subject less, allowing him or her to act more naturally. As a result, the images are typically more narrative or storytelling—especially when related moments are captured in sequence. For instance, a child may swing in a swing, play in the sand, walk down a path, or feed

Consider narrative activities and props to enhance your portrait and make the child feel more natural and comfortable. Photo by Kay Eskridge.

FACING PAGE—Narrative environmental sessions can be defined as outdoor portrait sessions, which allow for a more natural, expressive-type portraiture. Photograph by Vicki Popwell.

some ducks. The negative side of narrative portrait sessions is that the lighting and weather will affect your final result. Be cognizant of the type of lighting that's available, especially if you are using open shade or photographing at twilight. Also consider how the selected setting works with the child's attire. If the subject is wearing a frilly little dress, then an old, rusty car or a dilapidated fence won't make the best backdrop. A Victorian setting may be more appropriate.

With narrative sessions, an assistant may be helpful, because you are typically working in a larger open area. Often an assistant is needed just to communicate with the child, because the photographer may be too far away for the subject to hear any directions given. An assistant can coach the child to pose in a position that may appear more normal and natural. Many studios use the assistant to read books or play games with the child. Their involvement can stimulate expressions and responses. Props can also be used to stimulate or distract, which may help in creating a response or reaction from the child. You may consider adding Adirondack chairs, miniature benches, silk flowers, or a little red wagon to your props lineup. Alternately, you can ask parents to bring these or similar items.

■ CLASSIC STUDIO PORTRAITS

Our classic studio portrait sessions are created in a controlled studio environment. Whether your studio uses an umbrella or a softbox, a hair light, a background light, or a fill light, the joy of classic portraiture lies in finding a method that creates the results you prefer and then being able to reproduce them over and over again. With studio

Remember that backgrounds, scenes, and props must be as nice as or nicer than items in the client's home or they won't purchase a large portrait. Image by Kay Eskridge.

FACING PAGE—Our classic studio portrait sessions are created in a controlled studio environment. Photograph by Gregory Daniel.

portraiture, you are also able to use more standard backgrounds, creating more of a classic look to flatter any attire. After all, it is easy to change a backdrop than an environmental background. For an in-studio children's portrait session, create a proper setting for your children. When decorating your studio, work to create a noncommercial atmosphere. Set the scene by playing calming music, and work to make the client feel at home. Also, for comfort and safety, pad the floor.

With a classic style of portraiture, an assistant may or may not be used depending on the studio space you have to work with and whether the parents will be permitted to interact with the children. No matter what, do not leave the child unattended. Make certain supervision is close by. If using an assistant, have them make noise, be silly, sing, and play with toys that light up and play music—whatever it takes to entertain the baby and get a reaction. Like the environmental portrait session, props can often stimulate a reaction from your client and create an expressive response. Consider using a sleigh/bassinet, pearls, chiffon or tulle, books, angel wings, Halloween costumes, silk flowers, and a posing pillow to your props collection (to save money on your posing pillow, consider purchasing a "Boppy" from a local baby store. The cost is only about $25 and the function is the same as many of the posing pillows sold at conventions).

Remember that backgrounds, scenes, and props must be as nice as or nicer than items in the client's home or they won't purchase a large

Adding props to your indoor portraiture also helps to make the child feel more at ease and less threatened by the lights and studio atmosphere. Photo by Vicki Popwell.

portrait. Review and shop store catalogs such as Pottery Barn for Kids, Strasburg Children, Home Decorators, Ballard Designs, and Z Gallerie. All of these stores appeal to a higher-end clientele and offer interesting, unique approaches and options for clothing, props, and even background tapestries. Once you know what type of session you will be conducting and the approach you are going to take, it is just a matter of putting your camera to work. Coach your assistant and select your props, and you are halfway through the formula required for making your children's portrait business thrive!

Choose props and sets that will appeal to the type of client you are photographing. A prop should be of the same quality as the items in your customer's home. Photo by Gregory Daniel.

8. PREPARING PROOFS

*T*hough many successful studios believe the sale begins during the client's session, it definitely continues in the post-session stages. If you don't properly prepare you images for presentation and do not select a proofing method that works for your clientele, your sales will suffer. In this chapter, we'll take a look at how proofs should be created. We'll also take a look at the various proofing methods that can be used.

■ PROOFING WORKFLOW

While proofs can be presented in a wide variety of ways, preparing your images for proofing isn't complicated. The proofing workflow involves three distinct steps:

- Download your images onto your computer, placing them in a work folder.
- Duplicate the work folder and delete any unusable images from this duplicate folder. (Aim to have fifty or sixty images in this folder.)
- Select twenty to thirty of the best images and place them in a folder labeled Proofs. Use your digital imaging program to fine-tune these images before showing them to the client. (Note: While making these enhancements means that you will not be able to proof the images immediately following the session, rest assured that by fine-tuning the images first, you will be presenting the very best possible images! Remember, the faster it appears that you can deliver the order, the more you depreciate the value of your work. If the client does need you to expedite the process, then make it appear as though you have made an exception in the workflow—and never get it done *too* quickly!)

Using the tools of the trade to expedite your workflow and produce the special images that appeal to your market doesn't make you less of

> By fine-tuning the images first, you will be presenting the very best possible images!

a photographer, it makes you a better one. There are many image-editing programs on the market, and when considering your options, it is easy to get overwhelmed. One of the most common tools used in the industry is a program by nik Multimedia called Color Efex Pro! (www.nikmultimedia.com). There are tons of effects available in this program, and you can select the ones that best suit your studio's niche. Also consider using Auto FX's Photographic Edges (www.autofx.com) to create a unique, high-quality look. When modifying your images, be careful not to get caught up in the special effects. Just because you can, doesn't mean you should! Keep your effects believable but effective. To learn more about software, see *Digital Photography for Children's and Family Portraiture* (2004) or *Professional Techniques for Digital Wedding Photography* (2nd Ed.; 2004), both from Amherst Media.

While we're on the subject, it's important to note that you should never modify the client's images *during* the proofing session. It will delay the proofing procedure and, if the client sees you making modifications quickly, it could lower their perceived value of your work. It may also make them resent any applicable retouching charges that they may incur.

If the client sees you making modifications quickly, it could lower their perceived value of your work.

■ PROOFING METHODS

Paper Proofs. For decades, paper proofing was the favored approach for many photographers. Oftentimes, they dropped the ball and risked losing sales by simply sending clients home with their proofs and hoping they would order. Needless to say, these photographers lost an opportunity to interact with the client and to grow their sales.

In recent years, more and more clients have purchased scanners, and unscrupulous clients often illegally scan and reproduce proofs. Needless to say, this also hurts the photographer's sales and profits.

Paper proofing has a downside for clients, too. With paper proofs, clients are responsible for showing their images to friends and family members and must take orders. This alone can be a drawback for the modern client.

Projection Proofing. In projection proofing, a projection device, such as an LCD projector, is used to project images onto a large viewing screen. This type of proofing eliminates the threat of illegal copying of images and provides the photographer with a chance to inform the client about the product.

There are other benefits to this method, too. By using framing software like GNP FrameWorks, you can also project a wide variety of

frames that suit the image. Because you can project these images in any of the standard portrait sizes, you can show your clients how a 16x20-inch print would look framed and hung on the wall.

CD/DVD Proofing. CD/DVD proofing allows clients to quickly view their images. Consider providing small, low-resolution (72dpi) photos, formatted as .jpg or .exe files. Such images cannot be printed successfully. These images are numbered for ordering purposes. While these images may be e-mailed (if the studio allows), they are generally still copyright-protected and are not printable.

Using the tools of the trade to expedite your workflow and capture your market helps create a unique look to your portraiture. Photo by Jeff Hawkins.

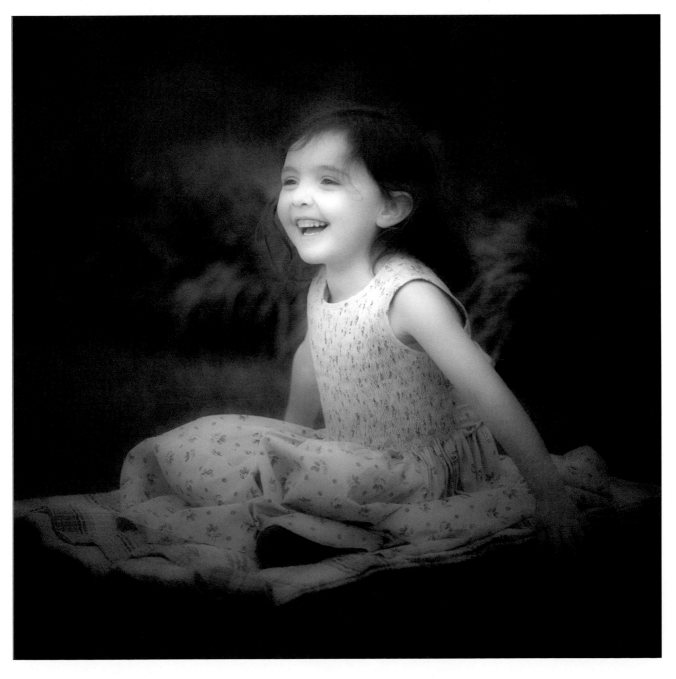

Due to concerns over illegal copying of images, some photographers are waiving their rights to copyright protection and releasing large, high-resolution digital image files to their clients after they have purchased their images. In most cases the files are "raw" and have not been cropped, sized, color-corrected, retouched, or otherwise enhanced. Many clients store these CDs/DVDs in a safety deposit box and can feel secure in knowing that they can have their heirloom images digitally enhanced and reprinted by the photographer should the need arise.

Online Ordering. Many studios have set up password-protected online proofing webpages for clients, their friends, and family members. Many studios also offer online sales, so clients and interested loved ones can place orders from the comfort of their home. It's best to offer this option for a limited time only. Be sure to make the start and end times clear to your clients before placing the images online.

Portfolio-Style Proofing. Some studios make up 8x10-inch contact sheets and bind them in a portfolio, allowing clients to share their proofs with family or friends. This is a great way to share images with a friend or relative who cannot view their images online or with a

Many studios have set up password-protected online proofing webpages.

Many studios have set up password-protected online proofing webpages for clients. Photo by Gregory Daniel.

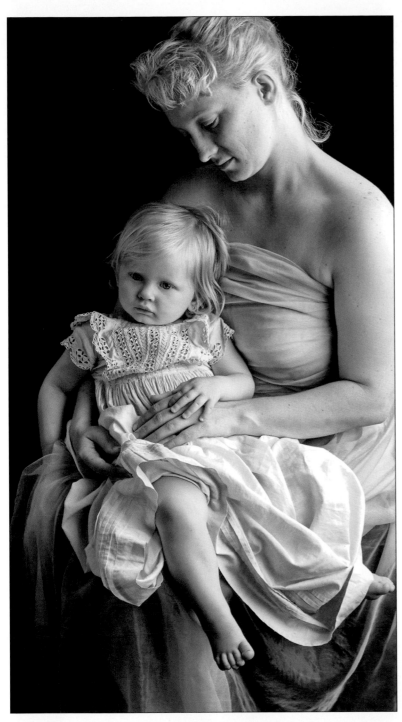

Photographer Vicki Popwell uses Fujifilm's Studio Master Pro and iPhoto to deliver her proofing presentations. She states, "After years of using paper previews we are quickly changing our procedures!" Digital proofing allows her to share her previews with technologically savvy clients, near or far. She does admit, that the digital process—from capture to proofing—is still something of a mystery for many clients. While explaining the details to these clients can be time-consuming, Vicki does educate her clients on the various digital processes.

CD/DVD. Be sure to set up guidelines for when (or whether) the portfolio must be returned to the studio.

■ PROFESSIONAL OPINIONS

Greg and Lesa Daniel. Greg and Lesa Daniel of Greg Daniel Photography have found great success in selling large, custom-framed images. The team attributes their success in selling these images to their use of the LCD projection method of proofing.

Greg says, "Our product presentation appears best with projection. Each session is presented in a theater projection room used exclusively for this purpose. The initial presentation of the images is arranged with music and displayed on a 50 x 50-foot movie screen that is electronically tucked away until needed. Once the mood is set, each image is viewed and products are featured. Signature wall portraits with Husar frames are displayed first, signature art pieces second, gift portraits third, and Art Leather albums are projected for the remainder. We utilize Image Select Pro (ISP) software. The ISP software allowed a seamless transition from film to digital for our clients."

Kay Eskridge. Phoenix Photographer Kay Eskridge uses a dual approach to proofing (though this varies based on the particular client's needs. She explains, "We use projection and portfolio proofing (contact sheets bound in a notebook). The only time we provide images online is for clients who have out-of-state family members. We've surveyed our regular clientele and have

found online ordering is not something they feel is important. They have come to trust us and value our one-on-one sales appointments, where questions can be answered and opinions can be offered. Our normal turnaround time is approximately one week for their portfolios (unless the client requires a faster turnaround)."

Sherri Ebert. Photographer Sherri Ebert prefers using a projection onto a flat-screen monitor. She says, "We proof portrait sessions via projection and use a flat-screen monitor placed in front of our clients. Large events are proofed via contact sheet "workbooks" that are print-ed in-house. Our studio offers online ordering through Collages .net, and we typically deliver images in a week or two."

Jamie Hayes and Mary Fisk-Taylor. Jamie Hayes and Mary Fisk-Taylor favor projection proofing, and have used it for many years. Jamie says, "We project all of our sessions and have since we opened the studio in 1995. We do not use paper proofs or online ordering. We feel that we would lose control of the sale and our client would have full control. We would be at their mercy. Using digital capture allows us the ability to have a clients' finished work delivered in just about any timeframe needed. We still have our clients schedule an appointment to order after the session is complete."

Jeff Hawkins. At Jeff Hawkins Photography, the proofing tools of choice are the LCD projected slide show and online proofing. However, they do not allow clients to view their images online until after the initial studio visit and sale are complete. Jeff says that if clients were willing to pay the price, paper

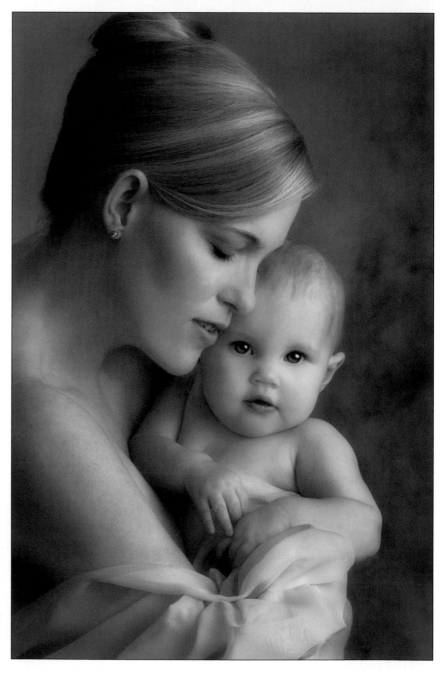

Jamie Hayes and Mary Fisk-Taylor favor projection proofing, and have used it for many years. Photo by Jamie Hayes.

At Jeff Hawkins Photography, an **LCD** projector is used to show the client their top images using **ACDsee**'s slide show mode. Photo by Jeff Hawkins.

proofs would be available for purchase. Anything can be sold for the right price!

Explaining the process further, Jeff says, "The proofing is handled in two ways. First, we produce a series of Artist's Choice images—portraits that have been artfully mastered, and to which our "studio look" has been applied. Using an LCD projector, we then show the client their top images using ACDsee's slide show mode. After they make their initial selections, we will go through once more and fine-tune their selections.

"Though the proofing process can be completed as early as the day of the session, we prefer to schedule it for a later date, as this allows us to master the images. We also utilize our online proofing service. This lets us generate larger sales from our clients' friends and family members. However, its primary role is to draw traffic to our website."

Charles and Jennifer Maring. Charles and Jennifer Maring recognize the value of a more interactive proofing style. Charles explains,

"We don't create paper proofs because we design original photographs that are worth a premium. Clients in our community value our opinion, so we would rather share the photographs via projection in our home theater and visually share the options of how to best display the art. Each client gets the benefit of our guidance in helping them make the decision that is appropriate for their lifestyle and their home."

Andy Marcus. Renowned photographer Andy Marcus relies mainly on paper proofs. His reasoning follows. "We do all of our image proofing with a program that lets us make 3 x 4-inch images of reasonable quality on a Xerox color laser printer. The proof sheets are printed on 8.5 x 11-inch paper and are of good—but not great—quality. The reason we do this is so that clients do not go to the nearest Kinko's and have the photographs copied. We can provide the service of online ordering, if so desired, but I have found that people would rather order one-on-one than online. Images up to 11 x 14 inches are all printed in my studio and can be delivered within a few hours of being ordered. Larger images are sent by FTP to my lab and can be delivered within a few days."

■ A VARIETY OF TOOLS

As you can see, there are several alternatives to traditional (paper) proofing. Most studios provide some form of online ordering to increase traffic to their website, to initiate orders from family and friends, and to gain public awareness and community exposure in offices and homes everywhere! People love to share their images with friends and family! Some of the most common solutions to meeting the challenges of posting images electronically can be found at the following websites: www.eventpix.com, www.morephotos.com, www.pictage.com, www.collages.net.

People love to share their images with friends and family!

From the above statements, it's obvious that most successful studios still believe in the power of a face-to-face proofing session. Note, too, that projection is a preferred proofing method for many pros, and for good reason: there's a common belief that showing larger images will lead the client to purchasing a larger print.

There are a variety of tools that you can use to facilitate the proofing process. Finding a product or service that best suits your business is a personal preference. Times are changing, and you must be sure that your service provider can grow with the technology and demands of the industry.

9. PRODUCTS AND MERCHANDISING

*S*uccessful portrait photography is about more than just new equipment and talented photographers. It is about analyzing the competition, establishing your market, and offering unique, in-demand products. Once you've established a signature style, focus on selling unique products that complement and enhance your art. Today's prints are presented in a more elegant—or dynamic—way than ever before. In this chapter, you'll learn about some of the products that are available and will learn how to make the sale.

■ PRODUCT PRESENTATION

The time your client spends in your lobby prior to meeting with you to view their proofs need not be downtime. In fact, by carefully selecting products to display, you can educate your client on what you offer and presell select items—without personally showing them a thing. This experience will prime them for your product presentations during the viewing of the proofs too.

The photography industry is ever changing, and so are your clients' needs. What makes one studio suffer and another successful? Studio

> The photography industry is ever changing, and so are your clients' needs.

What makes one studio suffer and another successful? Marketing is often the answer. Photo by Hayes and Fisk—The Art of Photography.

owners who fine-tune their merchandising strategies continue to thrive while the ones that don't, won't! Consider the following tips to increase your studio's bottom line!

Offer and Present a Few Carefully Chosen Products. Many photographers take pride in having lots of products for their client to choose from. However, if you offer and promote too many products, you can overwhelm your client. Identify a specific product you want to sell to your client and get the sale! Once that product has been successfully sold, you can move on to another product. Just be cautious not to spread yourself too thin or demand too much from your clients!

Push Your Client's Perceived Value of Your Products. When you convince your clients that their portrait product is a great value, your profits will grow. If you can build the value of a product in your client's mind, they will see the cost as reasonable and will make the

If you can build the value of a product in your client's mind, they will see the cost as reasonable. Photo by Jamie Hayes.

purchase (perceived value of a product = cost = purchase). For instance, if you sell clients on the value of the Lifetime Portrait Program, and they realize that the product they receive by signing up is a real *deal*, then they will make the purchase.

Create an Incentive Pricing Structure. Most large, successful companies have analyzed and researched their market and have developed proven marketing and sales strategies. Well, if they have spent the time and money creating these methods, consider following the leader. Don't reinvent the wheel! Use their example and implement a gift-with-purchase program, or try bundling your products together to create an incentive pricing structure (for instance, "Buy 3, get 1 Free!").

Package (and Protect) Your Products. Avoid selling loose, unframed prints when possible. Most of your clients have access to scan-

Avoid selling loose, unframed prints when possible. Photo by Jamie Hayes.

ners, photo copiers, computers, and printers. An image purchased in a frame with a sealed back is less likely to be torn apart and scanned. Likewise, an image presented in an album is also less likely to be scanned for fear of damaging the album. Show what you want to sell and make sure it is a complete product. Add a little finesse to your presentation with gift boxes, delivery bags, and bows!

Mark Each Product with a Price Tag. Design price tags for your products and merchandise your way to profit! Numerous studios have reported having trouble selling their framed images. Well, at many studios, it is difficult to tell which frames are available for sale and which frames are simply used to showcase the photographer's work. A consumer may be intrigued by what you have available but may be too intimidated to find out if it's in their budget. Pricing your well-merchandised products will put your clients in a shopping mode and take the intimidation out of the buying process! Create display signs in your studio (e.g., "Inventory Reduction Special," "10% Off All In-Stock Frames," or "Gift with Purchase Special"). When these signs are posted, they will continue to sell your products—even when you are not.

■ THE WHOLE STORY

As mentioned earlier, photographers who capture their images digitally take more portraits. With the price of film no longer a factor during a session, you'll find that you can likely string together a number of great shots in a way that really tells a story about your client's day.

Below are a variety of presentation options that go well beyond the more traditional single-image-in-a-frame delivery.

A Day in the Life Albums. Some of the top photographers in the country create narrative albums by following a subject from morning until night, capturing an editorial style of coverage.

Treasured Moments Coffee-Table Books. Other photographers digitally capture editorial-style images over several sessions to create a narrative album. Treasured Moments coffee-table books are often popular for a baby's-first-year session, a senior album, or even a kindergarten collection. While these completed albums can be expensive for clients, consider breaking down the purchase into smaller payments. For instance, if the total cost of the eighteen-page (nine double-sided pages) book is $2000, consider dividing that total by four. The client would pay $500 for each session—not $2000 at once. While capturing one of these sessions doesn't take as much time as a Day in the Life session, the profit level remains the same!

Guest Books. Several photographers are finding great success in taking the portrait session beyond the backdrop and into a storytelling scenario. This concept works great for baby showers and graduation-party guest books! With the purchase of a guest book, you'll provide your client with more narrative documentation (and *numerous* photos!) rather than just a couple of portraits. Many photographers utilize a Seldex nine-inch gallery album for a guest book. Art Leather's Euro Mini 77 is another popular option.

Little albums make great gifts for family members and are a fabulous gift-with-purchase incentive for the client! Photo by Maring Lifestyle Photography.

GNP FrameWorks software

helps clients to envision

how their images will look

in a variety of frames

Tiny Treasure Mini Albums. In addition to the fabulous sales opportunities that can be achieved with the above-referenced albums, several studios find success selling the smaller, Tiny Treasure albums. These albums are typically filled with images of a singular theme (e.g., the maternity theme, the "baby parts" theme, or a close-up expression theme). These little albums make great gifts for family members and are a fabulous gift-with-purchase incentive for the client!

Nine Ways to Say I Love You ("Baby Parts" Frame). This frame is ideal for newborns and can be displayed as a 5 x 30- or a 20 x 20-inch style frame. Typically showcased in this type of frame is a 3 x 3- or 4 x 4-inch image of the baby's face, plus a wide variety of shots of other adorable features (toes, fingers, ears, lips, butt, and belly button).

Frame Options. A custom wall folio (multiple-image frame) or larger custom frame is another good option for clients.

GNP FrameWorks software (www.gnpframe.com) helps clients to envision how their images will look in a variety of frames, from a very simple frame, to an elegant floating deckle-edge treatment or beautiful silk-screened matting with a fillet (a second "frame," made of thin molding, which sits between the image and the mat). The software also allows users to select a background (think "wall color") against which the framed portrait will be displayed, allowing clients to envision how the framed print will look in their home. Additionally, photographers can print a hard copy of the framed image or post the framed image online. Placing an order for frames is remarkably easy, too, with the implementation of a one-click ordering process.

There are many options available for creating unique products for your clients. By focusing on creating a specific product for the client's session, you won't overwhelm your client with too many choices. Photograph by Kay Eskridge.

A representative of Art Leather/GNP states that the software's many benefits include "being able to add your own prices for prints and frames, to creating orders and invoices in one step, to image cropping for client viewing, to dual-monitor output to tie into studio-projection systems, to complete background updates. Plus it works on all systems: Windows, Mac, Unix, and Linux."

Photographer Mary Fisk-Taylor feels that GNP FrameWorks software allows photographers to upsell clients to more expensive frames. "The visuals are excellent. The client can't resist when they see exactly how their images will look. We combine the software with the unique GNP MATCORS [a collection of 75 frame corners with corresponding mats] so the client can really see and feel the quality of the frames. It works!"

There are also many other companies that manufacture quality frames. When selecting a frame company, be certain to consider the cost of the frame *with* the wiring hardware and shipping costs are also factored in.

Using software like GNP's FrameWorks allows clients to see how their image will look in a variety of frames, a benefit that will help increase your sales. Photo by Hayes and Fisk—The Art of Photography.

■ ALBUM DESIGN TIPS

New album options are always available to photographers; therefore, there's always a learning curve when designing these albums for your clients. The following tips are useful when creating a storybook album.

- **Avoid panoramic prints.** They make your pages more vulnerable. If you want a panoramic feel or look, simply create a panoramic spread in Photoshop and then cut the image down the middle and mount the pieces separately.
- **Create color harmony from page to page.** Studios often photograph a variety of portrait backgrounds without considering how the images will work when combined with a vastly different background in the album. Keep in mind that the images should harmonize to create a cohesive design from page to page.
- **Limit the number of images that will appear on each page.** We have found that a three- to four-image limit can ensure an elegant look—and keep the focus on the images.

The client can't resist when they see exactly how their images will look.

- **Limit the number of collage pages.** In the end, less is best!
- **Just because you can, doesn't mean you should!** Avoid too many graphics and special effects! Keep the focus on the photography.
- **Limit the number of verses (or other wording).** Consider adding no more than one verse for every eight album pages purchased.

■ TEN MARKETING RULES FOR ALBUMS AND FRAMES

1. **You Have to Show It to Sell It!** You discovered a hot new product, now what? It is time to create your sample album. Always show the largest style and size your studio plans to offer. Clients can always visualize smaller but will seldom imagine a bigger product! Art Leather offers an album loaner program. Take advantage of it, and you can show a sample album while you assemble your client's images.

2. **Price it Profitably.** Analyze your costs and include them in your pricing for designing and proofing the album. With multiple images on each page and the design time factored in, your pricing should be equal to or greater than the price you charge for the 11 x 14-inch portraits in your package.

Both multi-image framing options and albums can be used when creating a story-telling image ensemble. Images by Sherri Ebert.

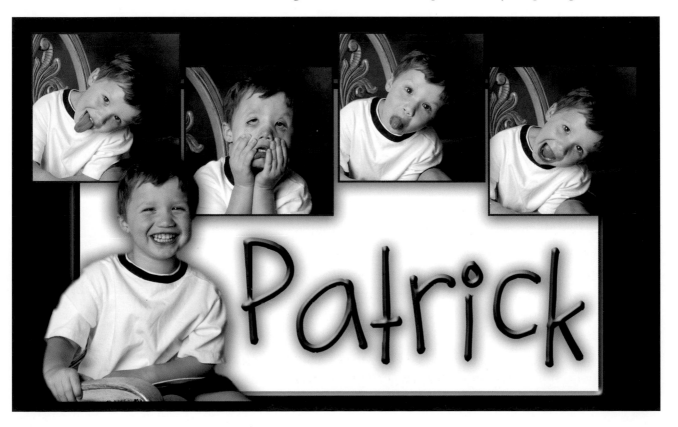

3. **Arm Yourself with the Tools of the Trade.** Be sure to try the new Montage Pro album design software program when creating an album: it will save you some precious production time. As you gain more experience, use Photoshop to create a more advanced or elaborate look to your pages. (Note: There are many template programs available that may actually add time to the design process. Make sure you don't select a program that confines your creativity. Think outside of the box!)

4. **Sell Your Albums Prior to the First Session.** Maintain control of your artwork and pre-sell the album prior to the session, allowing clients to add pages if needed afterward. Be sure to exercise restraint when creating your marketing material. Just because you can cram thirty images onto a panoramic spread doesn't mean you should. Consider limiting the amount of collage pages per book or creating an average of four images per page (side). The number of pages in the album is at the discretion of the designer.

5. **Create a Proofing Strategy.** Establish specific guidelines for the proofing process. At Jeff Hawkins Photography, we:

Don't let complicated designs deptract from your images—keep the focus on your portraits. Photograph by Sherri Ebert.

• Schedule an in-studio proofing session.
• Select images with the client.

Always show the largest style and size your studio plans to offer. Photograph by Sherri Ebert.

- Run a slide show of the selected images to ensure the story whole story has been told.
- Discuss design specifications (cover, important images, verses, etc.).

Once these items have been discussed, you are ready to begin the design process.

6. **Charge for Design Modifications.** Once the design is complete, submit it to the client via PDF, e-mail (use low-resolution files), or printed in a digital portfolio. Have the client initial and approve each page. As a suggestion, allow a certain number of basic design modifications. In a cover letter that accompanies the album, include a statement like: "Five basic modifications will be included in the design fee. There will be a $XX.XX charge for each additional modification. Image substitution and additional extensive design modification charges will be determined at the discretion of the designer."

7. **Increase Your Perceived Value.** Compare the wholesale investment of your specialty album to a traditional-style album.

Often, once you include printing and assembly, the cost of this album isn't much more substantial when you consider the caliber of the product and its perception in the market.

8. **Add a Gift-with-Purchase Program.** Two Tiny Treasures books can be purchased for only $75! These books are a wonderful source of advertising and make for a terrific incentive item that will increase your sales!

9. **Close with a Clause.** Add "caring for your album" tips in your thank-you note when delivering the product. Begin with a statement like "Because the album is printed on photographic paper, mounted, and library bound, proper care is required to protect its vulnerability." Following this statement, provide tips for keeping the album in peak form.

10. **Deliver with Dignity.** You have taken every step possible to prepare a high-quality product, now it's time to deliver it with dignity and class! The Montage art book ships in a durable box, but consider adding pizzazz to your presentation by delivering it in a high-quality slipcase or album bag that's imprinted with your studio's logo. (Both options are available through Art Leather.)

ABOVE—Consider limiting the amount of collage pages per book or creating an average of four images per page. Images by Jeff Hawkins. **FACING PAGE**—Don't select an album-design or image-editing program that confines your creativity. Photograph by Jeff Hawkins.

10. SOFTWARE

The old saying goes, if you don't know where you are going, any road will get you there. This philosophy is very true. Having precise goals and the knowledge to achieve them is crucial to your marketing success. There are a wide variety of software options that will help you to "know before you grow." Such programs can be used to facilitate every level of your business operations, from tracking client demographics, to editing images, to generating proofs.

There are a wide variety of software options that will help you to "know before you grow. Photo by Mary Fisk-Taylor.

■ STUDIO MANAGEMENT SOFTWARE

Studio management software is one of the best tools available to photographers. In short, it will help you to organize your business, achieve productivity gains, increase the quality of your customer service, and improve your studio's profitability.

One such program, Photo One (which is outlined briefly in chapter 4), is a real workhorse, providing customer-management features, invoicing, order tracking, detailed demographic-based marketing and promotions, and much, much more.

Mark Riffey of Granite Bear Development says that Photo One allows clients to enjoy a world of no lost orders, no missed appointments, and no struggling to deal with tax or commissions. The marketing component of this software

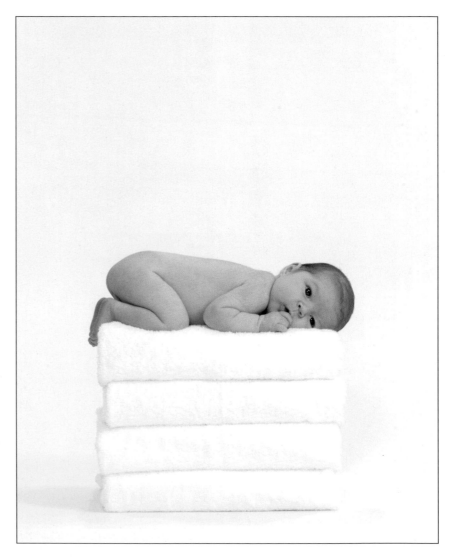

With a good marketing feature, you can track and target your marketing efforts by running reports that are broken down by schools, special interests (ballet, soccer, etc.), birthdays, ages, and much more. Photos by Vicki Popwell.

Zach

is remarkable: it allows you to track the amount and frequency of your clients' orders, identify particular demographics (ages, special interests, etc.), and track the success rate of various promotions. With such features, it's easy to see that using the software will allow you to sharpen your marketing strategies to target just the clients you want—and ensure that their particular interests are being served—in a matter of seconds and the click of a few buttons. Mark explains, "You may want to send a custom letter with the client's name, birthday, and other information about a special event for your best portrait customers. Send it to only those customers who spent $2000 in your studio last year, and those who have spent more than $10,000 in their entire relationship with your studio. You want to send this promotion to *families*—and only those who live in a really nice part of town. (Exclude those families who have indicated they don't want mailings from

The marketing component of Photo One allows you to track the amount and frequency of your clients' orders, identify particular demographics and track the success rate of various promotions. Photo by Vicki Popwell.

you.) Also, be sure to send a special version of the mailing to those customers who have motorcycles (or hang gliders, etc.).

■ WORKFLOW MANAGEMENT SOFTWARE

Good workflow management software is another indispensible tool. While there are many such programs on the market (and more available every day), Fujifilm's Studiomaster Pro (www.studiomasterpro) is one of the most effective programs around. Version 3 offers a slide show feature that can be exported, set to music, burned to a CD, and sold to clients (thus building revenue for your studio!) and also provides the ability to add your studio logo to your clients' prints. The software also delivers new networking functionality, allowing users to view, modify, and manage jobs easily between two or more computers. Archiving your images with this software is an easy task, too. You can commit your files to long-term storage and quickly access past orders, thereby enhancing your studio's organizational system and facilitating print orders down the line.

It goes without saying, when you save production time and improve performance—whether it be how you target and market to your clients or how you expedite and process your client files—you'll achieve greater customer satisfaction, which, of course, leads to higher profits!

When you save production time and improve performance you'll achieve greater customer satisfaction. Photo by Jeff Hawkins.

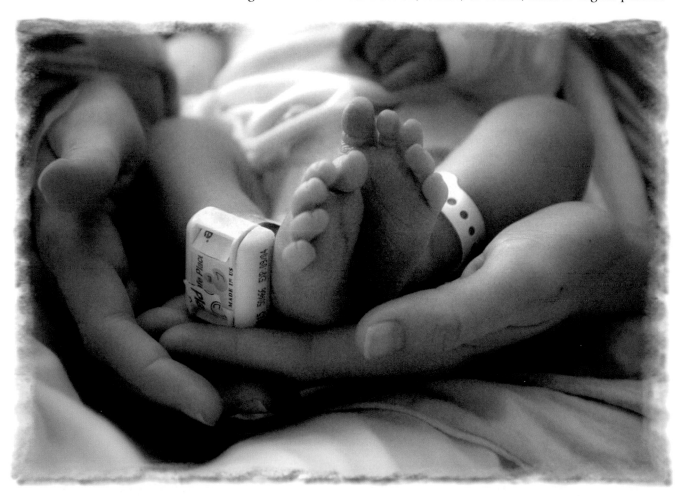

APPENDICES

APPENDIX 1—SAMPLE FORMS

PORTRAIT CLIENT INFORMATION FORM

SESSION DATE: _____

Name: _____ Spouse: _____

Children(s) names and birthdays: _____

Do you have any pets? ❏ Yes ❏ No If so, what kind? _____

Address: _____

City: _____ State: _____ Zip: _____

Home phone: _____ Work phone: _____ Cell phone:_____

Are you a Lifetime Portrait Club Member? ❏ Yes ❏ No

E-mail address: _____

Web page address: _____

PORTRAIT INTERESTS: *(Please check all that apply.)*
❏ Family ❏ Children ❏ Black & white ❏ Color ❏ Sepia

Size of prints typically desired: ❏ 5x7 ❏ 8x10 ❏ 11x14 ❏ 20x24 ❏ 30x40 ❏ Other _____

Do you usually custom frame your images? ❏ Yes ❏ No

Do you showcase your images in fine art albums? ❏ Yes ❏ No

Location of images to be displayed? ❏ Living room ❏ Bedroom ❏ Office ❏ Hall
❏ Other _____

How often do you have portraits taken? ❏ 3–6 months ❏ Yearly ❏ 3–5 years ❏ Other: _____

SPECIAL INSTRUCTIONS:

PHONE INTERVIEW QUESTIONNAIRE FOR PORTRAIT SESSIONS

Great! Let me just ask you a few questions to find out more about your portrait.

May I get your name? _____

How did you hear about us? _____

Have you seen our website or viewed our work? ❏ Yes ❏ No

Phone number: _____ E-mail address: _____

What type of photo session are you in need of?

How many people will be involved? _____

Is there a preferred portrait location (for example, your home, the beach, our studio, or a park)?

What types of products do you desire (albums, loose prints, framed images, etc.)?

Do you live locally? Are you available for a studio visit or would a phone interview be better? _____

When would be the best time to schedule an appointment? Morning or evening? This week or next?

Appointment date and time: _____ (❏ Phone ❏ In house)

RESPONSE TO PRICE REQUEST:

Basic Session (Individual Family Portrait Session)

Typically, the basic level portrait session is an average option. Each level, though, would be customized, based on the type of session, the frequency of sessions, and the location(s) selected. On an average, you can select from a $_____ session fee with products purchased à la carte, or a $_____ minimum product purchase commitment with no session fee required. Session location at the discretion and determination of Jeff Hawkins Photography. Session style: Classic family portraiture.

PLEASE E-MAIL: **DATE SENT:**

❏ Appointment directions _____

❏ Pricing questions before appointment _____

❏ Follow up (no appointment set) _____

IMAGE MODIFICATION FORM

First/last client name: _____

Portrait date: _____ Password online: _____

IMAGE NUMBER	PHOTO MANIPULATION TECHNIQUES

STATUS TRACKING FORM

ACTIVITY	PERFORMED BY	DATE
IMAGE MODIFICATION		
IMAGES ONLINE		
STOCK PHOTOS ORDERED		
WORK FOLDER CD BURNED		

STOCK PHOTOS

IMAGE	VENDOR

PORTRAIT PHOTOGRAPHY CONTRACT (PAGE 1 OF 4)

MEMBERSHIP SELECTED:	MEMBERSHIP ENROLLMENT DATE:	DATE:

Name: _____ Spouse: _____

Address: _____

City: _____ State: _____ Zip: _____

Home phone: _____ Work phone: _____ Alternate phone: _____

E-mail address: _____

Occupation: _____ Date of birth: _____

Spouse's occupation: _____ Spouse's date of birth: _____

Children(s) names and ages: _____

Pets to be photographed? ❏ Yes ❏ No If so, names: _____

PRODUCT INTERESTS:

Albums: _____ Style: _____ Frame sizes: ❏ 30x40 ❏ 20x24 ❏ 16x20 ❏ 11x14 ❏ 8x10

Desk art gifts: ❏ 10x10 ❏ 8x8 ❏ 8x10 ❏ 5x7 ❏ 5x5 ❏ 4x6

Notes: _____

PAYMENT REQUIRED:

$ _____ Total charges

$ _____ Sales tax

$ _____ Total due

$ _____ Non-refundable retainer (date paid: _____)

$ _____ Balance due (date paid: _____)

I agree to pay the fees required.

_____ _____
Client Date

DESCRIPTION OF SERVICES

PAYMENT	SESSION DATES
_____	DUE _____
_____	DUE _____
_____	DUE _____
_____	DUE _____
_____	DUE _____
_____	DUE _____
_____	DUE _____

PLAN PURCHASED:
❏ Lifetime Portrait
❏ Baby Plan
❏ Year in the Life
❏ Portrait Session

This agreement, entered into on _____ is between Jeff Hawkins Photography, Inc. in the State of Florida and doing business as Jeff Hawkins Photography and the undersigned (hereinafter referred to as Client) relating to the portrait session of _____.

_____ *int* **Service Coverage.** The parties agree that Jeff Hawkins Photography will furnish the services of a professional photographer. Jeff Hawkins or a trained associate (if needed) will provide photographic services. The fee for item/membership (exclusive of products) is $_____. Simultaneous photographic coverage by another person or contracted photographer shall release Jeff Hawkins from this agreement and the professional/membership fee will be retained. In addition, we request that guests or family members not take pictures of our setup/posed images; doing so may delay the process and effect or ruin the outcome of your photographs. We cannot guarantee any specific photograph or pose. We will, however, attempt to honor specific requests.

_____ *int* **Payment Policy and Expenses.** A fee of $_____ is placed as a retainer herewith to purchase referenced services. This fee is nonrefundable, but may be reapplied (subject to availability) if the session is rescheduled. All purchases will be paid by the Client at the time the order is placed. If the final purchase price exceeds what was paid, the new balance must be paid before production can begin. The selection of the portrait album photographs must begin within two weeks of viewing the previews or the album designed layout. With respect to product credits, credits and applicable products not used/ordered within six months of receiving the previews will be forfeited.

Contractual modifications to this agreement may be subject to a $150.00 service charge.

_____ *int* **Portrait of a Lifetime Program.** Program length available for the duration of the client's life or the life of Jeff Hawkins Portrait Photography, Inc., whichever is greater or in such event that the business is dissolved. Times and locations subject to availability and determined at the discretion of Jeff Hawkins Photography, Inc. Based on the type of session, number of people being photographed, and the location, a minimum product purchase may be required. Portrait sessions not used will be forfeited. Program membership is nonrefundable or transferable. Sessions based upon availability.

_____ *int* **Baby Plan Membership Guidelines.** Plan includes eight sessions and one color/unretouched 8x10 from each session. Sessions must be used within five years from the contract date or the remaining sessions will be forfeited. The 8x10 must be selected from each separate session and cannot be combined. Each session includes one location, outfit, and prop and must be used by one child. Additional portrait subjects will incur a separate session fee. All dates, times, and locations are subject to availability and at the discretion of Jeff Hawkins Photography. Plan is nonrefundable or transferable.

_____ *int* **Year in the Life Program Package.** Designer Art Book product credit is nonrefundable but may be applied to a product purchase. Sessions will be broken down over a one year period. The Book is required to go into production no later than one and a half years after the initial purchase date or the credit paid is forfeited. To participate in the Year in the Life Program, a Premier or Ultimate Designer product purchase must be committed to and deposits retained prior to session.

Signature: _____

_____ *int* **Product Pricing.** Pricing is defined on the attached price list. All prices quoted for professional services, photographs, and albums are valid for a period of two months following the date of the session. Orders placed after two months following the session are billed at the studio's currently published prices, which may be greater.

_____ *int* **Limitation of Liability.** While every reasonable effort will be made to produce and deliver outstanding photographs of the session, Jeff Hawkins Photography's entire liability to the Client for claim, loss or injury arising from Jeff Hawkins Photography's performance is limited to a refund to the Client of the amount paid for services. Jeff Hawkins Photography cannot guarantee delivery of any specifically requested image(s). As mentioned above, if our services are canceled for any reason, the retainer paid to reserve the date is *nonrefundable and the membership fee is forfeited.* In the unlikely event of a personal illness or other circumstances beyond the control of Jeff Hawkins Photography, a substitute photographer of high qualifications, subject to the acceptance by the Client prior to the event, may be dispatched by Jeff Hawkins Photography to fulfill the obligations of photography herein contracted. In such case that the Client declines Jeff Hawkins Photography sending a substitute photographer, the Client may elect instead to reschedule the appointment. No refund will be given if the Client elects cancellation of the Portrait of a Lifetime Program. In the event there is a dispute under this contract, the parties agree that the loser will pay the winner reasonable attorneys' fees. The venue shall reside in Seminole County, Florida.

_____ *int* **Federal Copyright Laws.** Jeff Hawkins Photography owns all original files, and unless specified, these are not part of any package. We retain the rights to reproduction of any images produced in connection with the agreement. Copying or reproduction in any form, unless released, of any photograph is hereby prohibited and protected under Federal Copyright Laws, and enforced to the full extent of the law allowable.

_____ *int* **Album Orders.** Using special design techniques, Jeff Hawkins Photography will advise in the layout of the album(s), however, all choices by the Client will prevail. One design session is included with each album/book purchased. If the client requests an additional design session, a $250.00 fee will apply. To begin construction on the album(s) a deposit of half the half of the remaining balance is required. The balance will be due upon approval of the layout. *In the event of a cancellation of a Designer Art book and unused album credit can only be applied toward a product credit and based on the discretion of Jeff Hawkins Photography.* Orders placed after two months of previewing your images will be priced at the studio's currently published prices, which may be greater. Following the notification of the completion of order, unpaid balances will be subject to a 2.5% monthly service charge. We are not responsible for albums left unclaimed after sixty days. Items not claimed and picked up after sixty days may be used for stock and studio display and monies paid will be forfeited. Delivery of Jeff Hawkins Photography's hand assembled albums is usually within nine to twelve weeks after the receipt of the order. This time may vary based on the size and style of the album(s).

_____ *int* **Ordering Reprints.** If we are to mail orders, appropriate shipping/handling and insurance fees will be added. We are not liable for loss, damaged product, or mishandled packages. If images are lost/damaged, you must seek remedies from the carrier.

Signature: _____

PORTRAIT PHOTOGRAPHY CONTRACT (PAGE 3 OF 4)

Model Release. Notwithstanding the foregoing, the parties agree that Jeff Hawkins Photography may reproduce, publish, or exhibit a judicious selection of such photographs as samples of photographic work to be shown to prospective clients in the form of in-studio displays, advertising, web site, and for instructional or institutional purposes consistent with the highest standards of taste and judgment.

For the good and valuable consideration, receipt of which is hereby acknowledged, I consent that the photographer, his legal representative, successors or assigns shall have the absolute right and permission to copyright, publish, use, sell or assign any photographic portraits on me taken on this or any subsequent dates, whether apart from or in conjunction with my own fictitious name, or thereof, in color or otherwise. Guests should be advised that photographs taken at the event are subject to use in the aforementioned uses.

I hereby release, discharge, and agree to save harmless their legal representative or assigns and all persons acting under the permission or authority or those for whom they are acting, from liability by virtue of any blurring, distorting, alteration, optical illusion, or use in composite form whether intentional or otherwise, which may occur or be produced in the taking of said picture and the publication thereof.

I hereby waive any right that I may have to inspect and/or approve any finished product or the advertising copy that may be used in connection therewith, or the use to which it may be applied.

I hereby warrant that I am of full age and have every right to contract in my own name in the above regard. I state further that I have read the above authorization and release prior to the execution, and that I am fully familiar with its contents.

There are four pages to this agreement. Please sign each page.

Client:_____

Guardian (if under the age of 18):_____

Date:_____

Facsimile signature deemed to be original.

JHP:_____

Date:_____

Facsimile signature deemed to be original.

Authorizes agent for Jeff Hawkins Photography.

APPENDIX 2—SAMPLE E-MAIL CORRESPONDENCE

Provided here are samples of the e-mail correspondence that we send to clients during the varying stages of the business relationship—from sign-on to the delivery of the final images.

■ PORTRAIT GUIDELINES

(This form is sent to clients once their portrait session has been scheduled.)

Hello!

Thank you for choosing Joe Smith Photography. We are so excited to work with you!

We have scheduled your session for *(date)* at *(time)*. Your session will include an online ordering feature that will make ordering easier for you and your family. These images will be posted after you view your images at our in-studio proofing session.

To familiarize yourself with our beautiful images, please have your family and friends view our professional portfolio at www.joesmith.com.

Session Requirements and Policies

- Each session price includes one outfit and one location.
- When scheduling a session, please indicate whether the session will take place indoors or outdoors. (Note that we typically conduct maternity and 0–3-month sessions indoors.)
- When traveling to an on-location session, payment is required at the time of booking.

Props for Children's Portraits

- Hats, sunglasses, and any other little extras are always fun!
- Mom reading a book with a favorite stuffed animal in the background makes for an heirloom-quality image.
- What do Mom and Dad do? Kids love to play dress up, so bring in part of a parent's uniform (or other occupational prop) and let them play!
- What can she/he sit in? Bringing your own props often makes the image more personal. Consider bringing a bassinet, a basket, big flower pots, or cooking pans—anything she/he can sit in to keep them upright. Add a baby doll, a baby carriage, a big teddy bear, or little red wagon just for fun! We'll add props from there.
- Mom and Dad should come to the session prepared to make an appearance in the frame—even if not entirely! The inclusion of a body part—even just a parent's hand or a part of the leg—illustrates the love between a parent and child. Sometimes parents are the best props!

Family Groupings

- Choose outfits that fit your personality and make you feel attractive. Create color harmony and ensure that all outfits are coordinated. Avoid patterns or stripes; solid, neutral colors look best. Avoid wearing short skirts or shorts, as they make posing more difficult. Long, flowing dresses, jeans, and khakis make better selections.
- Start thinking about props! This can make your photograph unique. Consider a picnic basket, wine glasses, a musical instrument, or even pets. We can also work with larger objects such as boats, sports cars, planes, or motorcycles.
- Don't worry about the location! Once you choose your wardrobe and props, schedule your appointment and we will discuss a location and times with you. We have access to many secret hideaways. Just tell us what you envision, and we will create the rest!
- Become alert to interesting photographs. Look out for awesome postcards or magazine adver-

tisements. Often we re-create art with you as the subject!

• Have fun! Let us capture you being you!

• Keep in mind that many families choose to display their portraits. Consider a designer frame, guest book (great for birthdays, showers, or celebrations), and holiday greeting cards. Also keep in mind that framed portraits make great gifts!

Remember, photography is not expensive, it is priceless! You will surely cherish this family heirloom for a lifetime. Again, thank you for choosing Joe Smith Photography.

■ THANK YOU FOR YOUR ORDER

(To be used following the in-studio proofing session.)

Hello, and thank you for your order today!

You and your family can view the images created at your session by visiting our website. First, go to www.joesmith.com, then click on Ordering, go to your name, and type in your child's name as the password. (For security reasons, we can not distribute passwords. Please contact your friends and family directly with the password information.) Let us know if you have any problems. Feel free to call us directly at 555-123-1234 or 1-800-555-1234.

Again, congratulations, and thank you for allowing us to capture your special memories. We think your images look incredible!

■ ONLINE IMAGES ABOUT TO BE REMOVED

(Sending an e-mail like this one to your clients will motivate procrastinators to hurry up and place their orders.)

Hello!

Just wanted to let you know that your online images will be removed from the site on *(date)*. Please encourage your friends and family members to visit the website soon if they are interested in ordering images. Visit www.joesmith.com, go to ordering, locate your name, and type in your password. You may elect to leave your images online for an additional sixty days for only $99.00. Please let us know if you would like to do so. Have a great day!

■ THANK YOU FOR YOUR ONLINE ORDER

(This is sent to clients once their online image order has been placed.)

Thank you for your order! We appreciate your business and will begin production as quickly as possible. Typically, print orders take two to four weeks and album orders take eight to twelve weeks for processing. Our office will be sure to contact you as soon as your order is complete.

In the meantime, feel free to contact us at 555-123-1234 or 1-800-555-1234 with questions or concerns.

■ THANK YOU FOR YOUR CONSULTATION (OR DID NOT SECURE SESSION)

(If your client visited the studio but didn't schedule a session, don't give up. Send a "thank-you for your consultation" letter.)

Hello!

Just a note to say it was great meeting with you and we look forward to the opportunity to working with you and your family! We hope to—and are excited to—hear from you soon. Please give us a call at 555-123-1234 or 1-800-555-1234 to secure a session date and begin the paperwork as soon as possible. Don't delay . . . dates book up quickly. Remember, photography is not expensive, it is priceless! You never get a second chance to capture these moments!

Again, thank you for considering Joe Smith Photography.

■ SHIPMENT CONFIRMATION

(Send non-local clients a confirmation e-mail that thanks them for their order and tells them that their images have shipped. Be sure to provide a tracking number for the client's package.)

Hello!

Thank you so much for your order! We appreciate your business. Your order has shipped via *(shipper)* and your tracking number is *(number)*.

Feel free to call us at 555-123-1234 or 1-800-555-1234, or e-mail us at joe@joesmith.com with questions or concerns.

■ GETAWAY SESSION PROMOTION

(Send e-mail updates to your clients to keep them posted about upcoming getaway sessions. If you design a template, you won't need to re-create the letter each time.)

Our family Lifetime Portrait club members can take advantage of a getaway portrait session and have their pictures made at a great location—with no session or travel charge!

On July 20–23, 20XX, we'll be holding sessions at *(location)*. Sessions will be held every hour and will last approximately forty-five minutes. Feel free to bring a friend or family member along: we can do two or three groupings just as easily as we can do one during your session time.

Terms and Conditions

Spaces and times are subject to availability.

Based on the length of time, size of the family groupings, and number of photographs requested, on-location portrait sessions may have a $150 minimum purchase requirement, which can be applied to the purchase of frames, guest books, miscellaneous prints, or any other product on our á la carte price list.

Due to the fact that a limited amount of session space is available, it is important that you modify your scheduled appointment time a minimum of one week prior to the session. All late cancellations will be subject to a $150 cancellation fee. If you are unavailable to participate on the specified date or do not want to adhere the minimum product purchase requirement, you are more than welcome to schedule a local session on another date.

Please select the date and time that appeal to you and call us at 555-123-1234 or 1-800-555-1234, or e-mail us at joe@joesmith.com, to secure your spot.

Sign up today! Spots are reserved on a first come, first serve basis (and the holidays will be here before you know it!).

(Close with a list of the available dates and times)

■ COFFEE-TABLE ALBUMS

(Include this letter with the delivery of the Treasured Moments or Day in the Life coffee-table albums.)

Hello!

Congratulations on your new album! It was a pleasure working with you on this endeavor. To ensure that your album is all you dreamed it would be, please be sure to review the book within 24 hours of its receipt. Please be sure to contact us if you have any concerns!

We hope you will enjoy your album for years to come, and want to give you some pointers on protecting your family heirloom.

To best protect your investment, please take the following steps to protect your album.

• Because your album was printed on professional photographic paper, mounted, and library bound, it should be stored flat and in a low-humidity location. If humidity adheres to the

product, simply move it to an area with low humidity, lay the album flat, and place a weight on top of the album. Once the water evaporates from the mount board, the pages will return to the original state.

If the warping occurred in your home, consider placing a dehumidifier in the room in which you plan to showcase your product (especially if you live in a humid climate such as ours in Florida)! The dehumidifier will not only be better for your album but will also help to protect your furniture and other belongings.

- Do not leave your family heirloom in your car or other high heat/humidity area!
- Insure your family heirloom immediately. Take out a rider on your homeowner's insurance policy to cover your investment in case the album is ever lost or damaged.
- Make several duplicate copies of your image CD/DVD and protect your family images. Store the duplicate copies in a safe environment, kept separate from the original copy and from your album.

Again, we hope that you will cherish your heirloom product for years to come!

Best wishes in all your future endeavors.

APPENDIX 3—CONTRIBUTORS AND RESOURCES

■ CONTRIBUTING PHOTOGRAPHERS

Gregory and Lesa Daniel
Gregory Daniel Photography
712 Garden St.
Titusville, FL 32796
321-269-1567

Frank Donnino
Donnino Gallery Portraits
3452 W. Boynton Beach Blvd. #6
Boynton Beach, FL 33436
561-732-1414
www.frank.nu

Sherri Ebert
Sherri Ebert Photography
805 Lapoma Way
Jacksonville, FL 32259
Phone: 904-230-8137
www.ebertimages.com

Kay Eskridge
Images by Kay & Co.
1343 E. Northern Ave.
Phoenix, AZ 85020
602-393-9333
www.imagesbykay.com

Jeff Hawkins
Jeff Hawkins Photography
327 Wilma St.
Longwood, FL 32750
407-834-8023
www.jeffhawkins.com

Jamie Hayes, Mary Fisk-Taylor
Hayes & Fisk—The Art of Photography
1003 N. Parham Rd.
Richmond, VA 23229
804-740-9307
www.hayesandfisk.com

Andy Marcus
Fred Marcus Photography
245 West 72nd St.
New York, NY 10023
212-873-5588
www.fredmarcus.com

Charles and Jennifer Maring
Maring Lifestyle Photography
824 C East Center St.
Wallingford, CT 06492
203-294-4700
www.maringphoto.com

Vicki Popwell
Vicki Popwell—Portrait Artist
PO Box 297
$4^{1}/_{2}$ East Court Sq.
Andalusia, AL 36420
334-222-2727
www.vickipopwell.com

■ COMPANIES/INDUSTRY VENDORS

Art Leather Albums
45-10 94th St.
Elmhurst, NY 11373
1-800-822-5286
www.artleather.com

Buckeye Color Lab
5143 Stoneham Rd.
North Canton, OH 44720
1-800-433-1292
www.buckeyecolor.com

GNP (Gross National Product)
18314-6 Oxnard Street
Tarzana, CA 91356
1-888-FRAME-GNP
www.gnpframes.com

Granite Bear Development
P.O. Box 1489
Columbia Falls, MT 59912-1489
1-888-428-2824
www.granitebear.com

Marathon Press
1500 Square Turn Blvd.
Norfolk, NE 68702-0407
1-800-228-0629
www.marathonpress.com

■ REFERENCED WEBSITES

www.autofx.com
www.eventpics.com
www.morephotos.com
www.nikmultimedia.com
www.photovisionvideo.com
www.ppa.com
www.studiomasterpro.com
www.wppinow.com

ABOUT THE AUTHOR

Kathleen Hawkins is an advisor and consultant to photographers throughout the country. She is the author of *Marketing and Selling Techniques for Digital Portrait Photography* (2005), *Digital Photography for Children and Family Portraiture* (2004), and *The Bride's Guide to Wedding Photography* (2003), all from Amherst Media. She and her husband Jeff operate an international award-winning wedding and portrait photography studio in Orlando, FL. Industry sponsored, they are both very active on the photography lecture circuit and take pride in their impact in the industry. They conduct private consultations and lead workshops at photography conventions worldwide, educating photographers on the products and services that create a successful business.

INDEX

A

Advertising, 33–43
Age of clients, 14
Albums
 assembling, 8
 baby, 60
 caring for, 106
 collage pages, 103
 color harmony in, 102
 Day in the Life, 100
 delivering, 106
 design, 102–3
 design modifications, 105
 homecoming sessions, 60–61
 images, number of, 102
 mini, 101
 panoramic prints in, 102
 perceived value, 105–6
 software, 104
 templates, 104
 text in, 103
 Treasured Moments
 coffee-table books, 100
Anniversary club, 30
Appearance
 of employees, 16, 18
 of studio, 16–18
 personal, 16, 18

B

Baby of the Month program, 31
Baby Parts frame, 101
Baby portrait sessions, 60–66
 0–3 months, 61–62
 3–6 months, 63
 6–9 months, 63–64
 12 months, 66

(Baby portrait sessions, cont'd)
 Baby Parts, 101
 delivery room, 60
 homecoming images, 60–61
 Tiny Treasures mini albums,
 101
Balance, achieving, 7
Birthday club, 30
Black & white images, 76
Booking a session, *see* Sessions,
 booking
Branding, 18
Business cards, 16
Business displays, 40–43
Business name, 33
Business training, 20

C

Calendars, 30
Cancellations, 48, 50, 52, 68
Chamber of Commerce, 31
Charities, fundraisers with, 31
Children, working with, 61–64,
 66, 75–76
Client-appreciation programs,
 24, 30
Client, evaluating needs of,
 56–59
Collages.net, 94, 96
Communication skills
 digital, discussing with
 clients, 58
 e-mail, *see* E-mail
 general, 19–20
 phone, 45–48
Consultation, pre-session,
 53–69

Contracts, portrait, 67–69
 availability clause, 68
 cancellation policy, 68
 copyright ownership, 69
 fees, itemized, 68
 model release, 69
 payment schedule, 68
 proofing policies, 68–69
 sample, 115–18
Copyright ownership, 69
Creativity, 79
Critical thinking, 20–21

D

Day in the Life program
 albums, 100
 sessions, 66–67
Delegating tasks, 6–8
Demographics, *see*
 Market, target
Department-store photography,
 17
Dependability, 20
Detours, avoiding, 8
Digital imaging
 advantages of, 70–82
 costs of, 70–73, 79–80
 discussing with clients, 58
Direct mail, 37–40
 image selection for, 40
 important features, 39
 timing, 39
 tracking results, 40
Displays
 mall, 18, 40–43, 73
 model releases for, 69
 studio, 69

E

Education, 20, 21–22, 75

E-mail, 35, 48

 sample letters, 119–22

Employees, appearance of, 16

Environmental portrait sessions, 83–85

Eventpix.com, 96

Experimentation, 76

F

Family, making time for, 5, 7

Famous clients, 31

FTP, 96

G

Getaway sessions, 27–28

Gift with Purchase program, 106

GNP FrameWorks, 101–2

Goals, setting, 8, 11

Guest books, 100

Guest speaking, 31

H

Holiday sessions, 64–65

I

Image modification form, 114

Income level of clients, 14

Insurance, 56

K

Kindergarten

 Day in the Life album, 100

 graduation portraits, 66

L

Lifetime Portrait program, 28–29, 98

Little Wonders program, 15–26

Location of clients, 14

Logo, 33

M

Magazines, researching demographics of, 20

Mall displays, 18, 40–43, 73

 model releases for, 69

Marathon Press, 21, 40

Market, target

 appealing to, 16–21

 common characteristics of, 14, 17

 identifying your, 11–22

Maternity sessions, 59–60

Merchandising, 97–106

Minimum orders, 49

Mini sessions, 52

Model releases, 69

Montage Pro, 104

Morephotos.com, 96

N

Niche, *see* Market, identifying your

O

Organizing your time, 5–10, 73, 77–78

P

Packaging products, 98–99

Personal appearance, 16

Phone skills, 45–48

 answering, 45–46

 appointment, asking for, 46

 contact information, providing, 47

 developing a rapport, 46

 e-mail confirmation, 48

 holding, 47

 interview questionnaire, 113

 paying attention, 46

 prices, discussing, 47

Photo One, 44, 108–10

PhotoVision, 22

Pictage.com, 96

Planning, 8

Portrait client information form, 112

Pricing, 50–52

 discussing, 47

 for profit, 103

 incentive-based, 98

 price tags, 99

Printing, 58

Product, determining type of, 12

Professional Photographers of America (PPA), 21

Profit, 5

Proofs

 CD, 91–92

 contact sheets, 94

 digital, 58, 94

 DVD, 91–92

 Image Select Pro, 93

 online, 92

 on screen, 94

 paper, 90, 95–96

 policies in contract, 68–69

 portfolio-style, 92–94

 preparing, 89–96, 104–5

 projection, 90–91, 93–94, 96

Props, 85, 87–88

Q

Qualifications, 18–19

Questionnaires, 20

R

Raffles, 30

Referral programs, 23–32

Referrals, 23

Religious events, 65

Rescheduling sessions, 50

Restaurants, promotions at, 30

Retouching, digital, 70, 77

S

Senior portraits, 66–67
Sessions
 baby portraits, 60–64
 booking, 44–52
 conducting, 83–88
 Day in the Life, 66–67, 100
 deposits/retainers, 48–52
 discussing on phone, 44–48
 e-mail confirmation, 48
 environmental, 83–85
 holiday, 64–65
 location of, 67
 maternity, 59–60
 senior portrait, 66–67
 special events, 65–67
 studio, 85–88
 time and day, 48
Session fee, 50
Skills required, 5
Software
 Montage Pro, 104
 Photo One, 44, 108–10
 studio-management, 44–45,
 108–11
 Studiomaster Pro, 111
 SuccessWare, 44–45
Specialization, importance of,
 14
Special offers, 24, 29–32
Studio
 appearance of, 16–18, 53–56
 clutter in, 54
 commercial space, 54
 décor, 54
 entrance to, 53
 image displays, 69, 97–106

(Studio, cont'd)
 insurance, 56
 location, 54
 low budget/high volume,
 17–18
 low volume/high budget, 18
 merchandising, 97–106
 refreshments, 55
Studio-management software,
 44–45, 108–11
Studiomaster Pro, 111
Studio portrait sessions, 85–88
Style, signature, 12, 33
Success, defining, 6–10
SuccessWare, 44–45
Suggestion box, 20
Summer Vacation Portrait
 Experience program,
 26–27
Survey cards, 20
Sweet-16 portraits, 66

T

Target market, *see*
 Market, target
Telephone, *see* Phone skills
Themed portraits, 29–30
Time management, 5–10, 73,
 77–80, 82
Tiny Treasures mini albums,
 101
Tracking your work, 7–8
Treasured Moments coffee-table
 books, 100

V

Value, perceived, 10

W

Wall folios, 101
Watch Me Grow program,
 24–25
Website
 appearance of, 16, 18
 backing up, 36
 contact information, 35, 37
 content, 19
 design, 8, 34–37
 first impression, 34–35
 Flash, 34
 home page, 37
 hours of operation, 37
 image selection, 35
 information page, 37
 JavaScript, 34
 links, avoiding, 36
 map, 37
 online ordering, 92
 organization, 35
 portfolio page, 37
 promotions on, 30–31, 37
 search engines, 37
 updating, 36–37
Wedding and Portrait Photog-
 raphers International
 (WPPI), 21
Workflow
 booking sessions, 44–52
 conducting sessions, 83–88
 expediting overall, 8–10
 management software, 111
 proofing, 89–96

By the Same Author . . .

PROFESSIONAL MARKETING & SELLING TECHNIQUES
FOR WEDDING PHOTOGRAPHERS

Jeff Hawkins and Kathleen Hawkins

Learn the business of wedding photography. Includes consultations, direct mail, advertising, internet marketing, and much more. $29.95 list, 8½x11, 128p, 80 color photos, order no. 1712.

DIGITAL PHOTOGRAPHY FOR CHILDREN'S AND FAMILY PORTRAITURE

Kathleen Hawkins

Discover how digital photography can boost your sales, enhance your creativity, and improve your studio's workflow. $29.95 list, 8½x11, 128p, 130 color images, index, order no. 1770.

THE BRIDE'S GUIDE TO WEDDING PHOTOGRAPHY

Kathleen Hawkins

Learn how to get the wedding photography of your dreams with tips from the pros. Perfect for brides (or photographers preparing clients for their wedding-day photography). $14.95 list, 9x6, 112p, 115 color photos, index, order no. 1755.

PROFESSIONAL TECHNIQUES FOR
DIGITAL WEDDING PHOTOGRAPHY, 2nd Ed.

Jeff Hawkins and Kathleen Hawkins

From selecting equipment, to marketing, to building a digital workflow, this book teaches how to make digital work for you. $29.95 list, 8½x11, 128p, 85 color images, order no. 1735.

WEDDING PHOTOJOURNALISM

Andy Marcus

Learn to create dramatic unposed wedding portraits with a contemporary feel. Working through the wedding from start to finish, you'll learn where to be, what to look for, and how to capture it. $29.95 list, 8½x11, 128p, 60 b&w photos, order no. 1656.

PORTRAIT PHOTOGRAPHER'S HANDBOOK, 2nd Ed.

Bill Hurter

Bill Hurter has compiled a step-by-step guide to portraiture that easily leads the reader through all phases of portrait photography. This book will be an asset to experienced photographers and beginners alike. $29.95 list, 8½x11, 128p, 175 color photos, order no. 1708.

STUDIO PORTRAIT PHOTOGRAPHY OF CHILDREN AND BABIES, 2nd Ed.

Marilyn Sholin

Work with the youngest portrait clients to create cherished images. Includes techniques for working with kids at every developmental stage, from infant to preschooler. $29.95 list, 8½x11, 128p, 90 color photos, order no. 1657.

MASTER POSING GUIDE FOR PORTRAIT PHOTOGRAPHERS

J. D. Wacker

Learn the techniques you need to pose single portrait subjects, couples, and groups for studio or location portraits. Includes techniques for photographing weddings, teams, children, special events, and much more. $29.95 list, 8½x11, 128p, 80 photos, order no. 1722.

CORRECTIVE LIGHTING AND POSING TECHNIQUES FOR PORTRAIT PHOTOGRAPHERS

Jeff Smith

Learn to make every client look his or her best by using lighting and posing to conceal real or imagined flaws—from baldness, to acne, to figure flaws. $29.95 list, 8½x11, 120p, 150 color photos, order no. 1711.

PROFESSIONAL DIGITAL PORTRAIT PHOTOGRAPHY

Jeff Smith

Because the learning curve is so steep, making the transition to digital can be frustrating. Author Jeff Smith shows readers how to shoot, edit, and retouch their images—while avoiding common pitfalls. $29.95 list, 8½x11, 128p, 100 color photos, order no. 1750.